BRITAIN IN OLD PHOTOGRAPHS

SNOWDONIA
IN AND AROUND THE
NATIONAL PARK

JIM ROBERTS

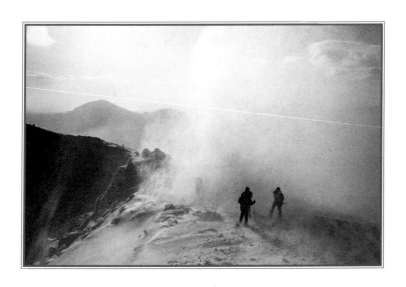

SUTTON PUBLISHING LIMITED

Sutton Publishing Limited
Phoenix Mill · Thrupp · Stroud
Gloucestershire · GL5 2BU

First published 2000

Copyright © Jim Roberts, 2000

Front Cover: Apprentice slate trimmers,
Blaenau Ffestiniog. Crib Goch and the
Snowdon Horse Shoe. *Title Page:* Crib-y-
Ddysgl, New Year's Day, 1997. *Back Cover:*
Sheep Shearing, Nant Ffrancon Valley.

British Library Cataloguing in Publication Data
A catalogue record for this book is available from the
British Library.

ISBN 0-7509-2267-2

Typeset in 10.5/13.5 Photina.
Typesetting and origination by
Sutton Publishing Limited.
Printed in Great Britain by
Ebenezer Baylis, Worcester.

Dedicated to my wife and family,
and to Harvey Lloyd, the most generous of friends.

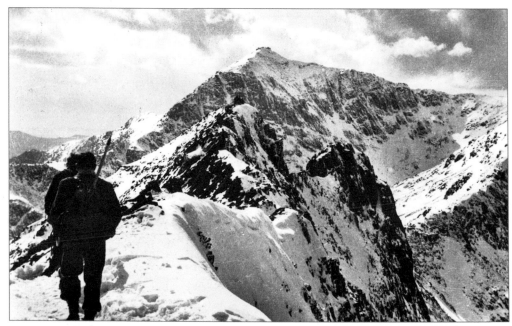

'I must not pass over in silence the mountains called by the Welsh Eryri, but by the British Snowdon, or Mountains of Snow, which . . . seem to rear their lofty summits even to the clouds.'
Giraldus Cambrensis, 1188.

CONTENTS

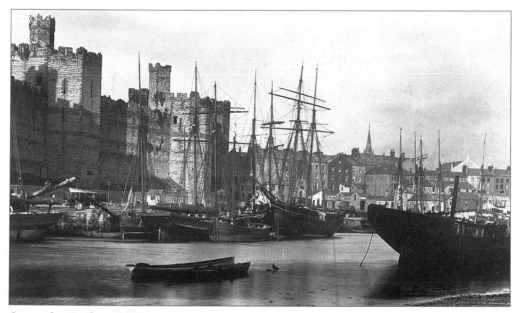

Caernarfon Castle, *c.* 1900.

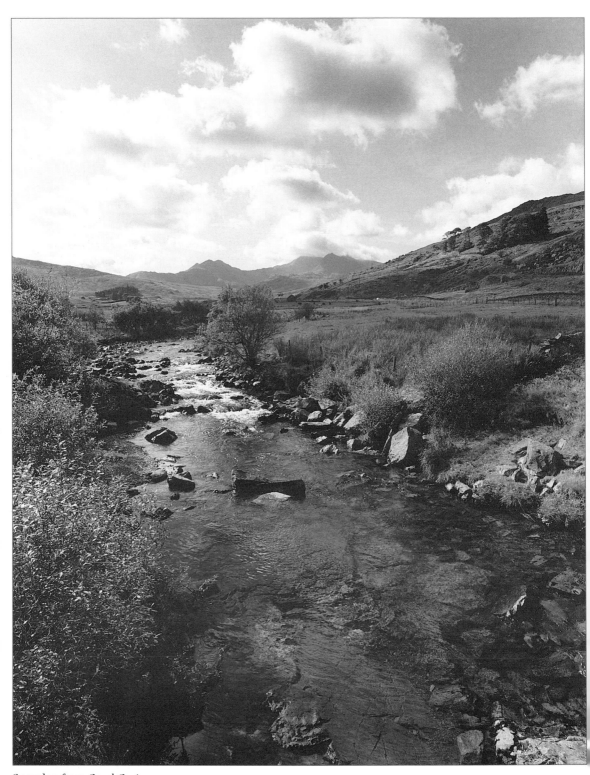

Snowdon from Capel Curig.

INTRODUCTION

The name Snowdonia referred to the mountains in the immediate vicinity of Snowdon up until the national park was established in 1951. From that date the name was applied to the whole area designated as the national park. The park is an area of some 838 square miles, stretching 50 miles from Conway to Aberdovey and 35 miles from Bala to Harlech in the shape of a diamond. The boundaries imposed upon it by the natural barriers of river, sea, moorland and mountain make it an area with its own ambience and integrity, an exciting place to visit and explore.

Throughout history the mountains of Wales and the Snowdon range in particular have been the last refuge and final stronghold of the island against the invaders sweeping in from the north, and from the Midlands and Cheshire plains. It could be said that even in the present day, the hills of Wales are the last refuge of a culture and a language far older than the English culture and tongue. Though life has been enriched by absorbing elements of other cultures introduced by invading foreigners such as the Romans, Normans, Irish and Anglo-Saxons, the traditions, customs and ways of thought have remained essentially Welsh, the product of a long history, experience and isolation. An estimated 65 per cent of people living in the national park speak Welsh as their language of choice.

Until late in the last century its physical boundaries made it a remote and inaccessible place. Accounts written by early travellers such as Pennant, Borrow and Bingley make fascinating reading since travelling then was truly an adventure. The road system, such as it was, was not designed for the visitor or explorer; the lanes and tracks were simply linking systems between the small, isolated communities. During the early years of the Industrial Revolution primitive road systems began to appear in response to the need for transporting slate and mineral ore to the seaboard. It was the need for communication between England and Ireland that gave rise to the construction of major roads such as Thomas Telford's road (now the A5) in the early nineteenth century. Despite the relative sophistication of the modern road system it is still possible to feel the wildness of Borrow's *Wild Wales* within a few seconds of leaving the road, and it is this characteristic of Snowdonia which must be preserved and not swamped by the desire to get from A to B at an even faster rate than at present. Currently there are moves afoot to modify the A470 through the Lledr Valley, arguably one of the most beautiful valleys in the world; plans to widen or to straighten the road could produce irreversible damage.

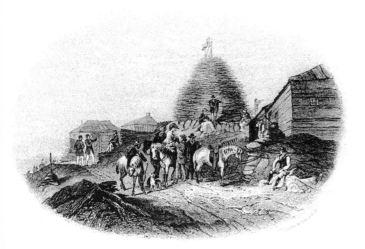

Snowdon Summit, *c.* 1860, from an engraving.

Since earliest times the whole area has been steeped in mystery, legend and romance. The Arthurian stories gathered together in *The Mabinogion* are situated, in the main, in these mountains. In it, for example, Arthur was killed on the Snowdon massif at Bwlch y Saethau (the Pass of the Arrows) and his knights still sleep in a cave on Lliwedd awaiting their recall to serve their king. The name of Merlin is associated with Dinas Emrys in Nant Gwynant. Sir Thomas Malory records one of the first Welsh climbs in *Le Morte d'Arthur* when he says, 'King Arthur goed up to the creste of the cragge and then he comforted himself with the colde wind'. There is a wide and varied literature by such writers as S. Baring-Gould, Showell Styles and Michael Senior recounting the fascinating mythology associated with North Wales.

Snowdonia is more than an area of superbly varied scenery; it is also a place where almost 30,000 people live and work. The mountains are a source of real material wealth. They provide water for taps, and for energy, they are grazing grounds for hundreds of thousands of sheep, their slopes are timber-farmed and opened for their minerals. The scars that scour the mountainsides with their attendant spoil heaps testify to the rock, slate and ores ripped, none too gently, from the ground. The Romans came for metals, and traces of their settlements abound throughout the region. Two thousand years of mineral exploitation have left their blemishes on the landscapes. Places such as Llanberis, Blaenau Ffestiniog and Bethesda have not been allocated national park status, but are included in this book because of their economic significance in the area's recent past and the interest such industrial history has for thousands of visitors each year.

Snowdonia has an obvious attraction for artists and many of the major artists of the nineteenth century spent time here capturing the picturesque and magnificent on their canvases and in their sketchbooks. When the science of photography became an applied art, photographers too started to come to the mountains. Henry White produced beautiful prints in 1856. Roger Fenton exhibited over twenty prints of North Wales in the Photographic Society in 1858. Francis Bedford travelled extensively throughout North Wales with his 10 in × 12 in plate camera and, between 1864 and 1868, his photographs were published by Catherall and Prichard. His photographs frequently show the carriage in which he travelled, and his assistant posed to provide human interest and size scale; he produced a memorable photograph of a busy Snowdon summit (see p. 9). Around the turn of the nineteenth

century the Abraham brothers of Keswick climbed and photographed in the mountains, and their pictures of climbers are classics of the genre. Today, cameras click incessantly in the area and there are many art photographers producing stunning images. Among them, for example, is John Clow, a poet and photographer whose two books *The Mountains of Snowdonia* and *Snowdonia Revisited* contain captivating atmospheric photographs.

In a publication of this type the selection of material is governed by the survival of the materials of human interest which are capable of decent reproduction. Many interesting aspects of the life of the inhabitants of Snowdonia during the reigns of Queen Victoria and King Edward VII are under-represented for want of suitable material. Photographers of the time were not pointing their cameras at the farmers, shepherds and quarrymen of the area but at the sublime and the magnificent in the landscape.

Research into pictorial history inevitably leads to the valuable source provided by the picture postcard. In the first twenty years or so of the twentieth century, Britain was awash in a flood of pictorial cards; postcard mania swept the country, and the picture postcard album was an obligatory part of Edwardian furniture. In 1894, after an era of printed non-pictorial cards, companies were given the go-ahead to produce pictorial cards, and these are now eagerly sought by collectors. In 1914, 900 million postcards were posted, the vast majority of them pictorial cards. The 'real photographic cards' produced by the major companies such as Judges, Valentines, Frith and Abrahams, and the smaller local suppliers such as village post offices and chemists' shops are the ones most sought after. Most of the photographs in this book started their lives as picture postcards.

Some £4 million was raised from public subscription to purchase the south side of Snowdon in 1998. A £1 million gift from Sir Anthony Hopkins was a considerable boost to the appeal fund, and the nation owes him its gratitude. Surprisingly, most of the land (69.9 per cent) in this 'national park' is privately owned; small portions of it were owned by the National Trust and now it will own the greater part of Snowdon itself, placing the mountain in safe hands.

There are many problems associated with the future of the park. There will continue to be conflicts of interest between the needs of the farmer and the needs of the visitor; most of these would be solved if the visitor adhered to the country code, with particular regard to gate-shutting and controlling of dogs. The demands for industrial development and expansion will have to be

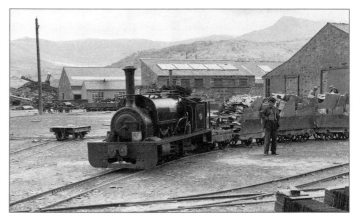

Nesta shunting at Penrhyn Quarry, *c.* 1956.

scrutinised with vigilance. An early belief that national parks would be exempted from industrial expansion was dealt a blow when a nuclear power station was built on the banks of the cooling waters of the lake at Trawsfynydd, and there have been attempts in recent years to create an opencast copper mine in the vicinity of Dolgellau. Forestry Commission expansion, with vast areas of conifers imposing a dull uniformity on the landscape, is being modified to meet the protests from those who wish for a more aesthetically pleasing crop. The forester's purchase of large areas for forestation precludes the use of that land by hill farmers who are already under tremendous pressure from other directions. The future for the hill farmer has recently become bleak indeed.

The park's own attractiveness is leading to its major problem, however, and that is how to deal with the vast numbers of people who visit it, a number that increases considerably each year. Visitors want better roads, easier access, shops, restaurants, picnic areas, hotels, hostels, toilets, etc. The tramping feet are doing tremendous physical damage to the hill and lakesides. The mother mountain is subjected to the pounding of over a million feet a year on its summit alone, and the tracks throughout the park suffer the cutting and grinding action of human feet incessantly. The park staff engage themselves sensitively when attending to these issues but problems arise. For example, when does 'repairing a track' become 'laying a path'? Will the signs of the future be 'Keep off the grass', 'This way to the summit' and 'Queue here for the Zig-Zags'?

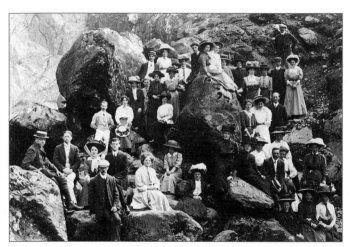

Early tourists in Snowdonia, *c.* 1890.

The International Union for Nature and Natural Resources Conservation (IUCN) set up a category of protected landscape, and called it Category V, and its objectives are, 'to maintain significant areas which are characteristic of the harmonious interaction of nature and culture, while providing opportunities for public enjoyment through recreation and tourism, and supporting the normal lifestyle and economic activities of these areas. These areas also serve scientific and educational purposes, as well as maintaining biological and cultural diversity.' Eryri falls into this category.

SNOWDON SUMMIT

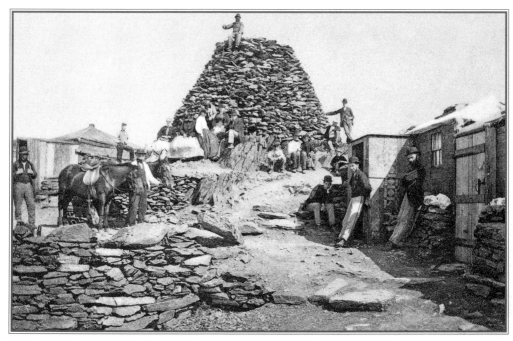

'A vast mist enveloped the whole circuit of the mountain. The prospect down was horrible. It gave an idea of numbers of abysses, concealed by a thick smoke furiously circulating about us. Very often a gust of wind formed an opening in the clouds which gave a fine and distinctive vista of lake and valley.' Thus Thomas Pennant described his impressions of Snowdon's summit in 1781. In legend, the summit is the grave of the giant Rhita Gower, a republican eco-warrior who slayed kings and rather than waste their beards wove them into warm shirts to keep out the chill winds of Eryri. He met his death at the hands of King Arthur and was buried under a cairn at the summit, hence the name Yr Wyddfa (tomb or borrow). Bwlch y Saethau between the summit and Lliwedd is where King Arthur met his maker, and his knights still sleep in a cave in the 'Slanting Gully' on Lliwedd awaiting their king's resurrection.

Francis Bedford took the photograph above in the mid-nineteenth century. Guides with ponies usually accompanied travellers. The charge per horse was 5s to the summit and 10s for a journey over the mountain, e.g. from Llanberis to Beddgelert. The fee for an average party from Beddgelert to the summit was 7s and over the mountain to Llanberis 10s. Each hotel in the area provided guides and ponies, a valuable source of income in an otherwise impoverished environment. Climbing Snowdon was an expensive venture and climbers were usually members of the middle, professional or upper classes. In the mid-nineteenth century approximately 10,000 people a year climbed the mountain, and by 1950 this had risen to around 400,000 (a large number availing themselves of the mountain railway). Nowadays in excess of 500,000 people a year reach the summit.

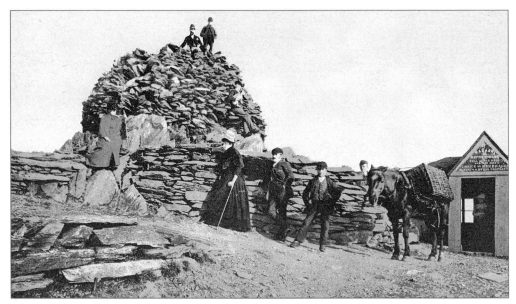

Young boys were frequently used as guides, after they had served an apprenticeship with their fathers. In the photograph above the clothing of the young lad next to the horse suggests that he is the guide. An entry in the visitors' book of 27 June 1850 records 'Guide, Edward Elias, boy 13 years, gave good satisfaction' and this was followed by the comment, 'We ascended Snowdon from Llanberis guided by instinct and a small boy.'

The summit buildings have been the source of much controversy over the years, as will be seen later. The summit cairn in the photograph is the second to have been built. The first was erected in 1827 by the Royal Engineers who were doing an ordnance survey; this was rebuilt in 1841 and the cairn seen here was the result. In the 1890s a Llanberis photographer, James Leach, made a living by taking photographs of the tourists at the summit. The picture below, it would seem, shows his camera stand on the shelf of stones in the foreground. He built a 'studio dark room' some 70 ft below the summit, thus making his contribution to the unsightly clutter. He paid the Vaynol Estate one guinea a year for the privilege.

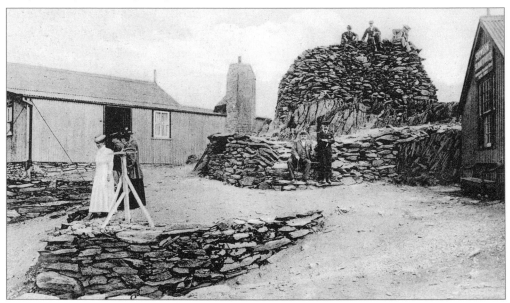

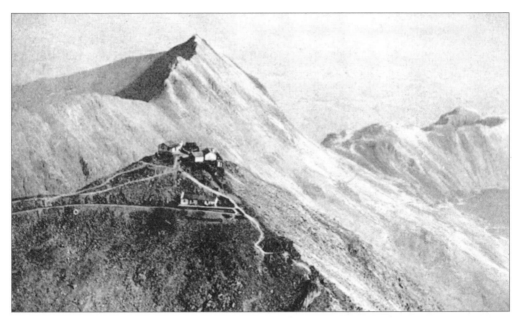

Imposing artificial structures on the natural environment inevitably leads to criticism from one source or another and this is the case with Snowdon's summit. In 1984 Prince Charles, during a visit there, called it the 'highest slum in the kingdom' and commentators throughout the years have stated much the same thing. F.S. Smythe, the celebrated mountain climber and photographer, in *Over Welsh Hills* (1942) said, 'Let me say at once that the summit of this mountain is the ugliest I know' and he later described the cairn as '. . . a superb example of misplaced energy on the part of those who built it'.

Above, a very early aerial photograph shows that conditions on the summit were appalling. Sordid materialism and the profit motive had triumphed over good sense and environmental concerns. There had been a long history of ugly hut building and wars between territorial claimants throughout the latter part of the nineteenth century. This continued until 1923 when the huts were cleared and the station was rebuilt. The photograph below was taken after 1923.

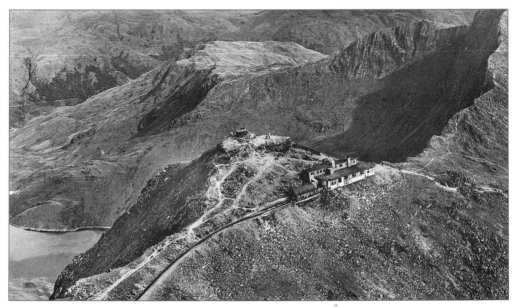

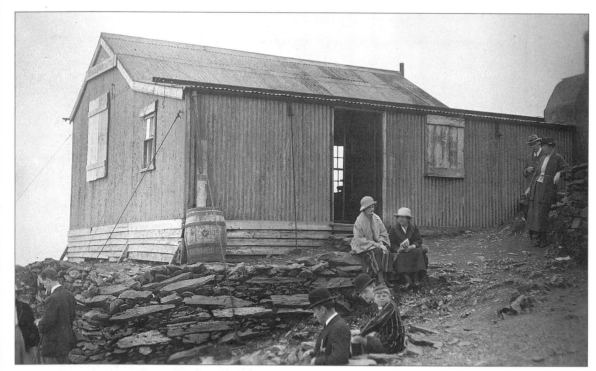

The 'before and after' photographs on this page seem to indicate what the mountain itself felt about the corrugated-iron abomination placed there.

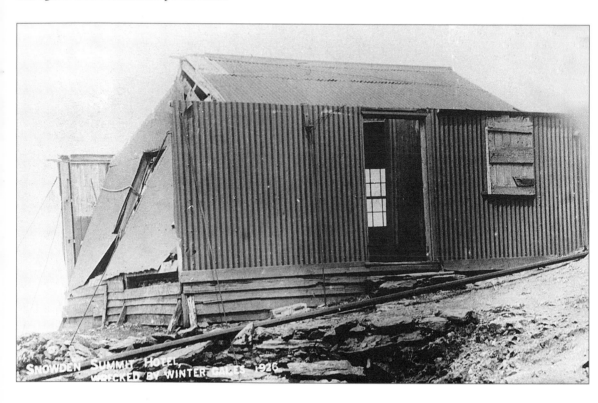

This photograph from the Harvey Lloyd Collection is a puzzle. It is taken on the shores of Llyn Llydaw around the turn of the nineteenth century. It is a temporary corrugated-iron structure, and fresh copper spoilheaps lie about. Is it a refreshment house to rival the Llanberis Track Halfway House, or is it a miners' barracks?

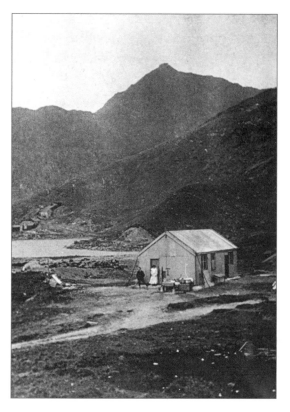

A red-letter day in the history of the mountain was 18 June 1887, a day on which Queen Victoria's Golden Jubilee was celebrated. A bonfire was lit on the summit at 10 p.m. and there was a firework display followed by entertainment and a singsong. At 12 o'clock the strains of 'God Save the Queen' and 'God Bless the Prince of Wales' were heard. The photograph below shows the wagons transporting the barrels of pitch and tar to the summit to ensure a good blaze.

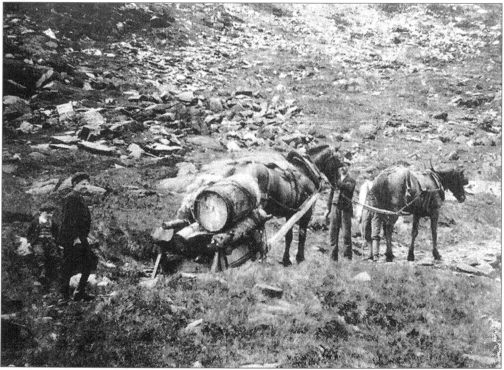

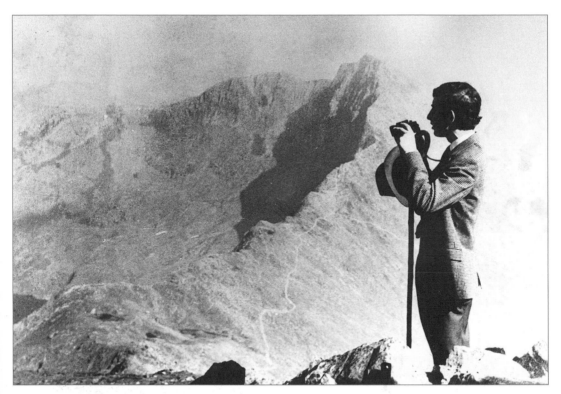

In the above photograph Prince Charles visits the summit in 1972, with Bwlch y Saethau in the background. The photograph below shows the summit as it is now, with a queue forming to stand on the highest peak in Wales or England.

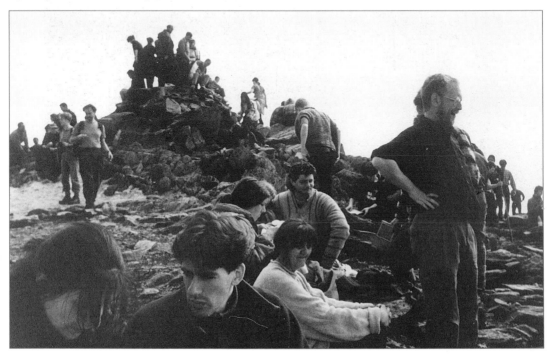

GETTING TO THE SUMMIT

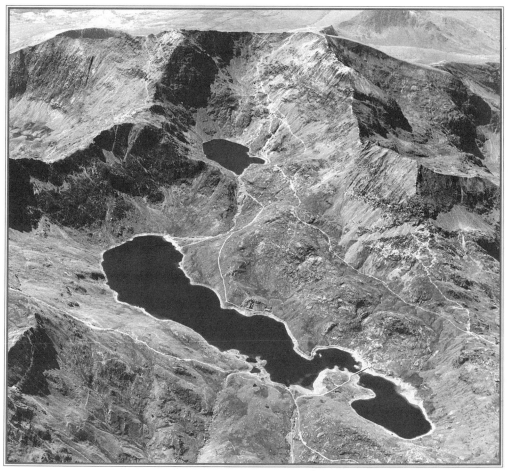

This superb aerial view shows the Snowdon massif spread like a contour map. The photograph was taken at 7,000 ft and flattens the mountain slope's perspective as a result. It shows the tracks worn by walkers to the summit and the Horseshoe is very clear. The Llanberis and Watkin paths come over the back of the mountain to the summit.

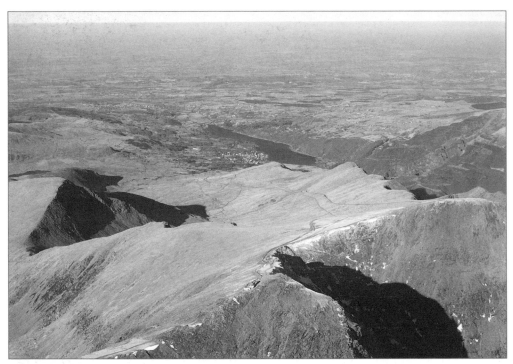

The Llanberis Path. The easiest but longest route to the summit, and the one generally chosen, is the 5-mile hike from near the Snowdon Mountain Railway, Llanberis, terminus. The route runs close to the railway track for almost its entire length, and at two points it goes underneath the railway. The aerial photograph above shows the path snaking up the mountain from Llanberis in the distance to where the summit sits at the meeting point of three ridges.

This is a relatively tedious pull up the mountain but is a very popular route and during the walk, providing the weather is right, the walker is rewarded with some splendid views. Users of the path are warned not to be lulled into a false sense of security by its apparent simplicity; in adverse weather conditions and during the winter it can be dangerous. Walkers must not trespass on the railway line!

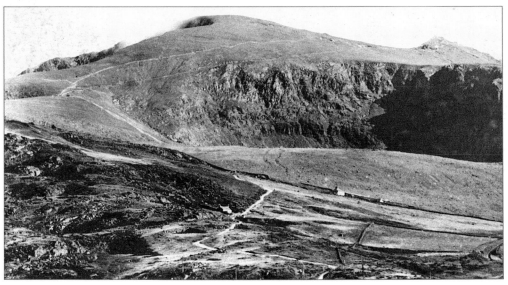

Four of the Roberts family on the Miners' Track, 1970, photograph by John Roberts, aged ten. This is either a very popular route to the summit or a pleasant stroll to the base of the mountain at Glaslyn. The track was used for the transport of ore from the copper mines on Snowdon. On this track there are the ruins left by mining activity in the area's industrial past: at Llyn Teryn and Glaslyn there are the remains of the barracks where the miners lived during the week, and there are derelict crushing and sorting mills on the shores of Llyn Llydaw.

When the Miners' Track reaches beyond Llyn Llydaw the panorama from Y Lliwedd on the left to Crib Goch on the right with Snowdon centre stage is one of the most often depicted and memorable views in Wales (below).

A steep walk up from Glaslyn joins with the Pig Track where they both meet the Zig-Zags.

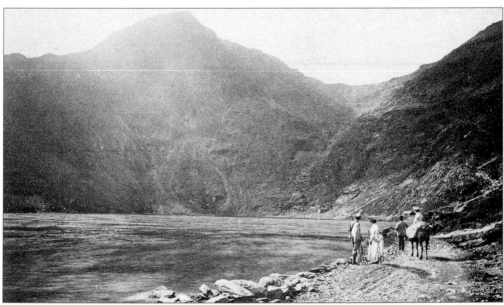

Victorians on the Miners' Track, a hundred years earlier.

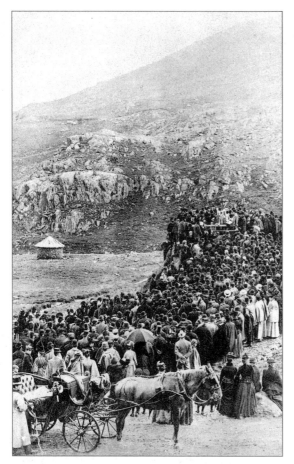

The Watkin Path. In 1892, aged eighty-four, William Ewart Gladstone talked to the Welsh nation about freedom and sovereignty for small states. The speech was made on the slopes of Snowdon, and Lloyd George and Tom Ellis were also on the platform. A vast crowd had gathered to hear his speech. There is a plaque on Gladstone Rock to commemorate the event. This speech marked the opening of the track, which was named after Sir Edward Watkin who had erected a chalet at its foot for the convenience of his friends who wished to climb Snowdon (see p. 23).

This route represents the longest climb to the summit, rising 3,370 ft from a start at 190 ft. The ruins of the South Snowdon Slate Quarry can be seen on this route, with deep pits making exploration a dangerous procedure. The path leads up to Bwlch y Saethau, the dip between Lliwedd and Y Wyddfa, and then, once along the ridge, it zigzags to the summit. This part is narrow and hazardous in mist or snow.

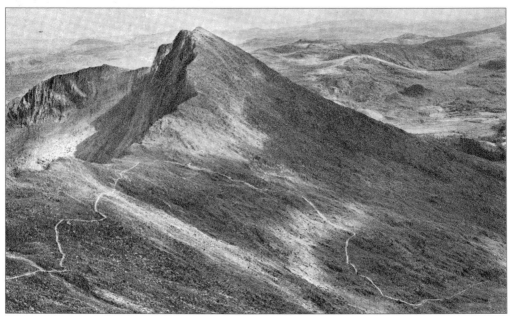

The Snowdon Ranger Track is another relatively simple track to the summit with the advantage of being shorter than the Llanberis Track by approximately 2 miles; the route starts at the Snowdon Ranger Youth Hostel. John Morton, one of the earliest of the mountain guides, was particularly proud of his guiding prowess and called himself 'The Snowdon Ranger' and named his house after himself. George Borrow remarks on his presence in his book *Wild Wales*. His house, much extended and rebuilt, became 'The Snowdon Ranger Hotel'. The route, which is well marked, ultimately joins the Llanberis Track a short walk from the summit.

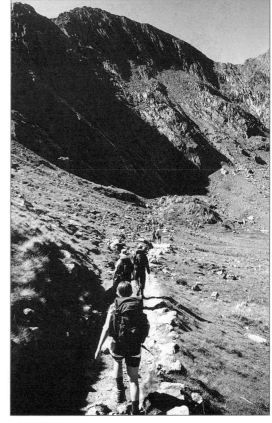

This route is called the Pyg Track either because visitors to the Pen y Gwryd Hotel used it or because it passed close to Bwlch y Moch (the Pass of the Pig). The climb is shorter, though steeper, than other routes. Its starting point is Pen y Pass at the top of the Llanberis Pass. This very popular route is clearly marked and easily followed as is shown in the accompanying photograph. The path goes to the left of Crib Goch and to the right of the old copper mine which appears a mile after leaving Crib Goch. The Zig-Zags start here and carry you steeply and quickly to the skyline above; from here you make for the railway tracks and the summit. Keep well to the right at this point to stay clear of precipitous cliffs to the left.

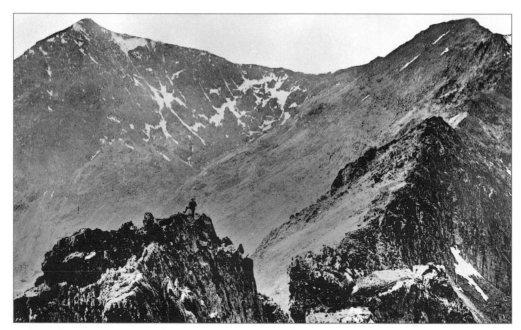

The Crib Goch route and Snowdon Horseshoe. Vertigo sufferers and the faint-hearted beware, this is not the route for you! This forms part of the world-famous 'Snowdon Horseshoe' and represents in places a serious scramble rather than a walk. The route starts with the Pyg Track at Peny y Pass but leaves it at Bwlch y Moch; the left fork is the Pyg Track, the Crib Goch path is the right fork. Superb and exciting views are a feature of this route, but it requires constant vigilance and concentration and a not inconsiderable amount of agility.

The Snowdon Horseshoe itself is probably the finest mountain ridge walk in Great Britain; it consists of the ascent of Snowdon via Crib Goch and Crib-y-Ddysgyl and the descent is made over Lliwedd.

The photograph below shows that this route can become very crowded at times and many people, seeing its popularity, assume that it is easy, only to regret it later on.

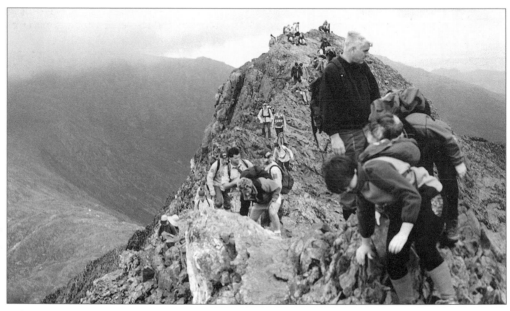

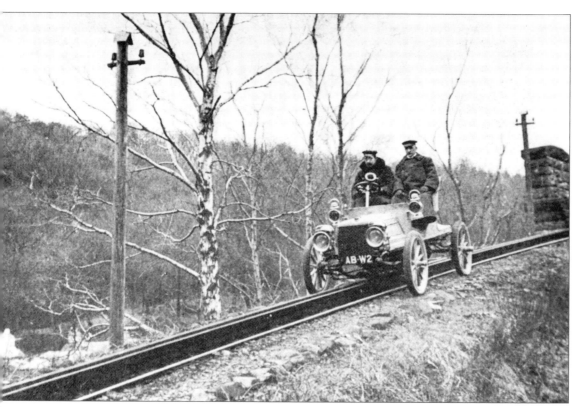

o the summit by motor vehicle. On 27 January 1904 Mr Harvey du Cros and Mr Charles Sangster drove a 15-hp
riel car from Birmingham to the foot of Snowdon. Mr Aitchison of the Mountain Railway Company put the track
t their disposal, as this was the only feasible route to the summit for a motor vehicle. The track was not in the
est condition, it was midwinter and there was a considerable amount of snow about. With chained rear wheel
e intrepid pair reached halfway on the first day. On the second day they got as far as Clogwyn, more than three-
uarters of the way to the top and here an enormous snowdrift stopped them. A fierce storm raged throughout
e attempt. Du Cros tried again on 26 May 1904 and reached the summit after experiencing various mechanical
roblems.

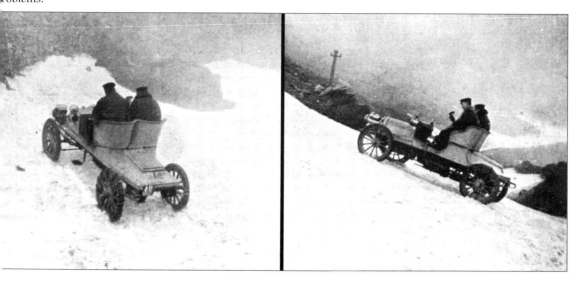

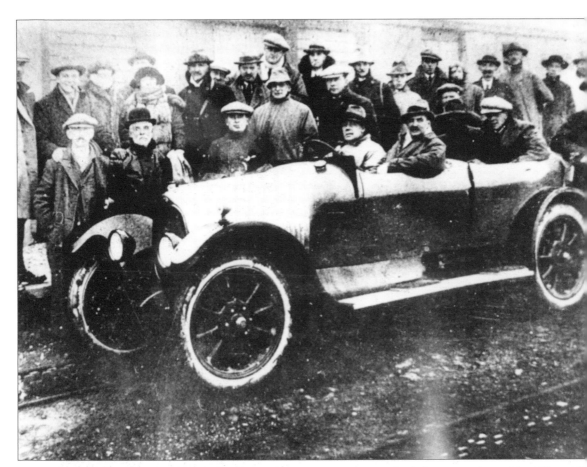

Two weeks after the first summit success Mr W.M. Letts of Llandudno reached the summit in a 5-hp Oldsmobile. The climb was achieved in 1 hour, 27 minutes. There were two more recorded motor car attempts in 1920 and 1951. The successful 1920 attempt, shown above, was by another Llandudno man, George Brown, the managing director of the North Wales Silver Motor Company. The car was a 14-hp Angus Anderson, and the journey to the summit took 3½ hours. In the photograph the car looks very similar to a bull-nosed Morris. The 1951 attempt was in a Land Rover driven by an army officer. Thankfully this way of getting to the summit stopped after this attempt. Protracted assaults by motor vehicles would have been an environmental disaster. In 1924 a motorcycle (2.75-hp BSA) roared up the mountain in an astonishing time of 24 minutes, 6 seconds.

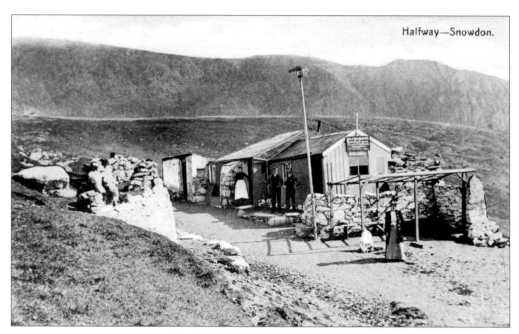

Halfway—Snowdon.

Halfway up the mountain on the Llanberis Track close to the Half Way station was the Halfway House. A Llanberis family, who came up every day during the season, owned this refreshment hut. They were famous for the quality of their secret recipe lemonade. At the moment it is a derelict site and a local man is waiting for planning approval to rebuild it. The people of Llanberis call the area below the hut and station Cwm Hetia (Hat Valley). The open carriages on some of the early trains, and the prevailing wind, provided Llanberis people with a selection of headgear free of charge if they cared to walk up the cwm.

The chalet built at the foot of the Watkin Path by Sir Edward Watkin, for the comfort of his guests who were ascending by the longest climb, in terms of height covered, to the summit.

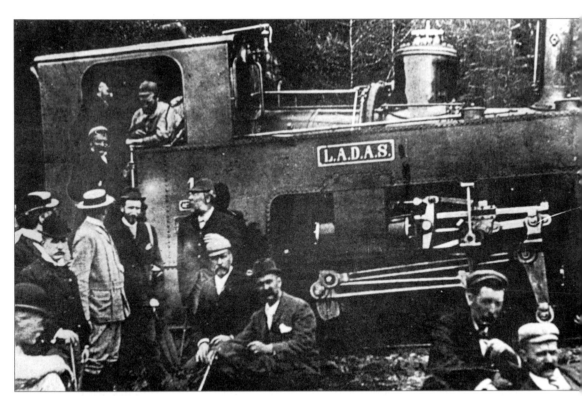

Ladas before the disaster, 1869. Work began on the Snowdon Mountain Railway on 15 December 1894 after som
hesitation about the correctness of such a project by Mr W.A. Assheton Smith who owned much of the mountair
Initial objection, led principally by Canon Rawnsley, who wrote several letters to the press condemning th
scheme, were overridden. The engineers were Sir Douglas and Francis Fox, and the secretary and general manage
was G.C. Aitcheson. Two viaducts had to be built before track laying could begin. Once they were completed, th
track was laid at a phenomenal rate of approximately 120 yd a day. The Abt system employed (see p. 26) require
a great deal of precision during construction. A lot of the work was carried out during the winter months, an
conditions for the workers were appalling. The first engine arrived at Caernarfon by sea from Antwerp in Jul
1885. It was promptly named *Ladas*, the initials of Lady Alice Duff Assheton Smith, the owner's daughter. A lett
from the engineer in charge stated, 'The 15 December when Miss Enid Assheton Smith cut the first sod was a re
letter day in the history of Llanberis.' The line opened officially on Easter Monday 1896 . . . and promptly clos
for a year on Easter Monday 1896 after a tragic accident on the inaugural journey. In the year it reopened
carried 12,000 passengers to the summit, and nowadays it averages in excess of 100,000 passengers a season.

These two photographs show what happened on the inauguration day. Train No. 1, *Ladas*, hit a stretch of line that had been affected by subsidence just above Clogwyn station. The engine plunged down a ravine but the crew managed to jump clear. The two carriages with their eighty passengers were brought to a halt by the brakeman Aitcheson who had been entrusted with this role for the first run. Two passengers defied Aitcheson's command to stay where they were and jumped for it. Ellis G. Roberts, of the Padarn Villa Hotel, died as a result of the wounds he received. An electrical fault caused by the accident triggered the go-ahead signal for the second train, which began its descent. The engine jumped the tracks at the same point. It ran down the rails and hit the stationary carriage of the first train, demolishing the second one and pushing the other to Clogwyn station. The impact knocked the engine back on to the track. The events of the first run led to the line being closed for a year so that a safety rail could be added and various modifications made to operating procedures to restore public confidence in the venture.

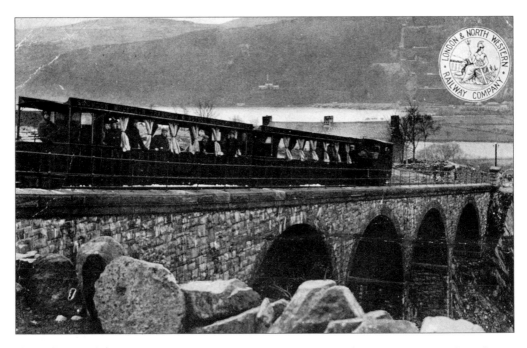

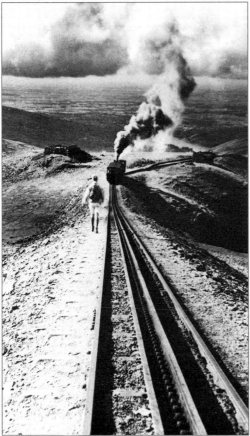

Two viaducts were constructed for the railway;
the Avon Hwch Viaduct (the lower viaduct) is
over 166 yd in length and has fourteen arches.
The whole viaduct is on a gradient so that
each arch is 4 ft higher than the one below it.
A little further up is the upper viaduct shown
here, just over 63 yd long with four arches.
The viaducts were built in bad weather during
the winter months of 1894/5. It took eight
months of construction before they were
considered of sufficient strength to take the
track. The absence of smoke in this photograph
indicates that the train is descending. The
coaches are pushed up the mountain by the
engine (puffing smoke), and the train is held in
check by the engine when it is descending, as
the motive power is then gravity. Good and
efficient braking systems are essential.

The standard Abt system which is used in the
track consists of two racks of teeth laid side by
side with the teeth staggered and never in
phase; this ensures that a train pinion is always
in contact with a rack tooth. This makes for a
smoother and much safer ride. Electric-powered
engines were rejected in favour of coal because
of cost, though if the Cwm Dyli power station
had been in operation the decision might have
been different. What the environmentalists
would have said about poles and overhead
electric wires is another matter.

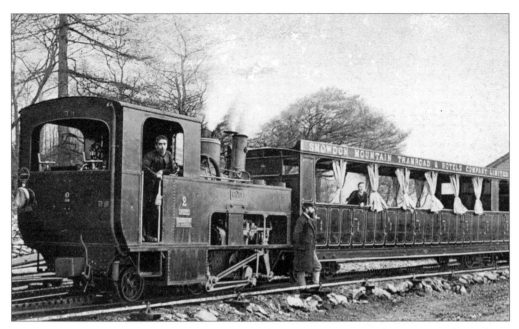

The first locomotives were built in Winterthur, Switzerland and transported by sea to Caernarfon. This is locomotive No. 2 *Enid* named after Mr Assheton Smith's other daughter. *Enid* is the oldest engine associated with the railway and played an important part in its construction as the transporter of building materials. This engine was purchased at the same time as the ill-fated *Ladas* and each cost £1,525.

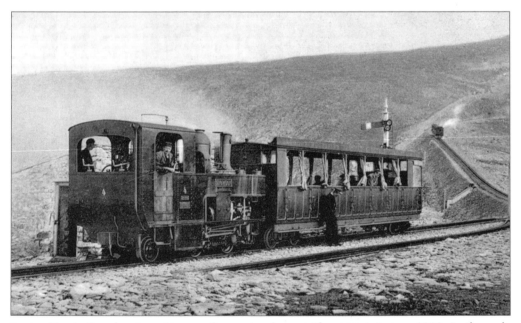

Engine No. 4, *Snowdon*, is waiting on the passing loop at Clogwyn station, *c.* 1910. In the early years, traffic was controlled by the semaphore system seen here. There were five working locomotives at this time. This one was taken out of service in 1939 and was a rusting derelict hulk at Llanberis until it was taken to the Hunslet Engine Company, Leeds for a complete overhaul in 1961. After its long rest it steamed again at Llanberis on 30 July 1963.

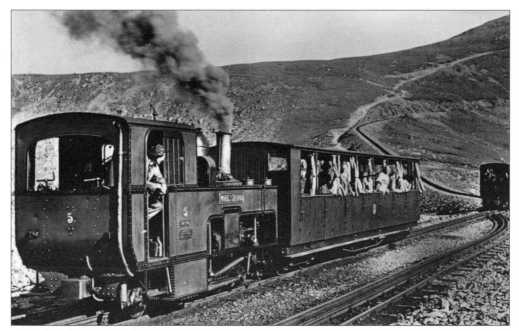

In this photograph the semaphone signalling system has gone, replaced by a telephone communication system and tickets of 'authorisation' issued by men stationed at passing loops. This locomotive, named *Moel Siabod*, arrived at Llanberis in 1897. Seven locomotives (0–4–2 T) were built in Switzerland between 1895 and 1924: *Enid* (2), *Wyddfa* (3), *Snowdon* (4), *Moel Siabod* (5), *Padarn* (6), *Ralph Sadler* (formerly *Aylwin*) (7), and *Eryri* (8).

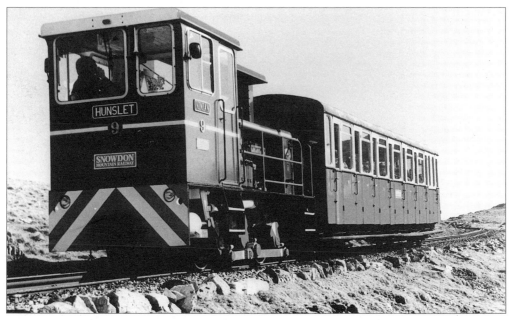

A share issue was launched in January 1985 and part of the raised capital was used to purchase two Hunslet diesel locomotives in 1986. No. 9, *Ninian*, is shown here, and the other was No. 10, *Yeti*. These engines are not intended to replace the steam fleet. They enable the company to run more trains at reduced operating costs.

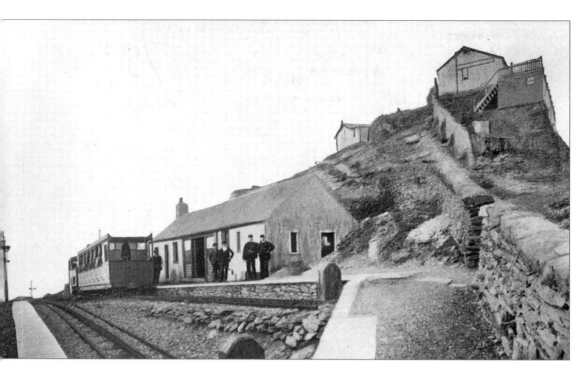

Two views of the summit station. Above is a view of *c.* 1910. The facilities shown here were for the exclusive use of the railway staff. Tourists were catered for in the ugly conglomeration of summit buildings, a part of which is visible here. This 'mess' existed at the top of the mountain until the late 1920s, when good sense prevailed over economic expediency (greed!) and they were removed. The building below is the new station and hotel (cafeteria) complex designed by Clough Williams-Ellis of Portmeirion – not the most inspired of his designs.

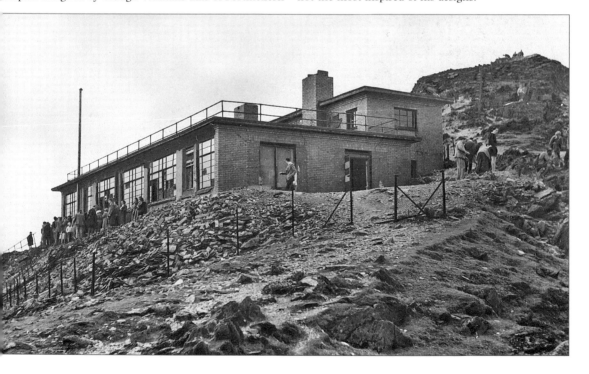

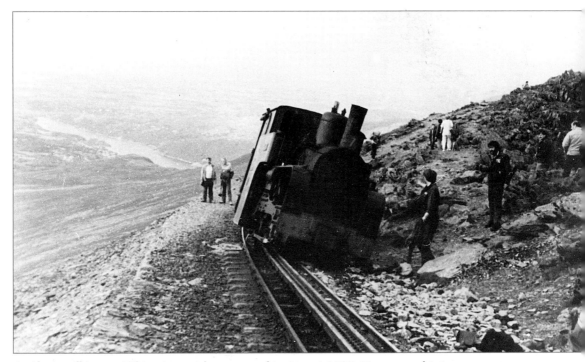

Accidents will happen! This minor mishap occurred in August 1987. No one was hurt.

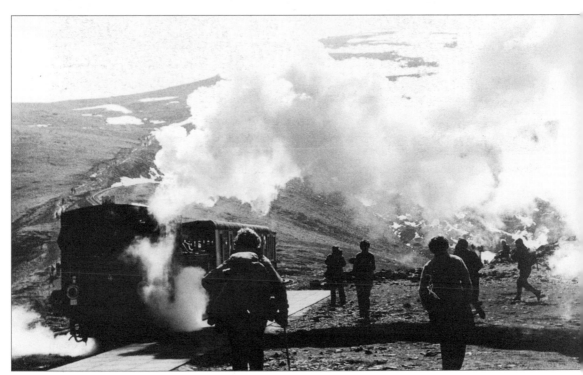

In 1996 a centenary celebration for the line was held, and enthusiasts from all over the country arrived to trave
to the summit. This photograph was taken on that day.

CHAPTER THREE

ROADS & ROAD TRANSPORT

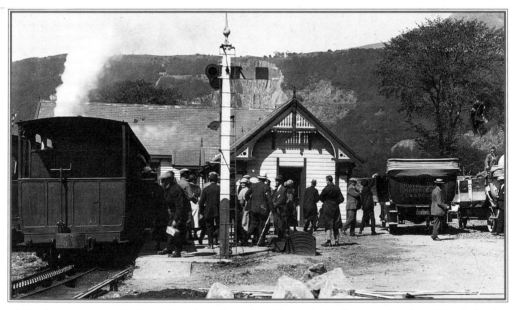

Mixed transport at Llanberis Terminus Snowdon Mountain Railway. A bus from Llandudno is disgorging passengers for the trip to the summit, c. 1920.

At the end of the eighteenth century conditions for travellers in North Wales were hardly any better than they had been for Giraldus Cambrensis in the twelfth century. Roads were almost non-existent and bridges over torrents were few and far between. Accounts of the early tours in the area are full of the extreme hardships faced by travellers. Indeed, there were few travellers in North Wales at the turn of the eighteenth century as compared with, for example, the English Lake District and Scotland. In *A Tour Through Wales and Monmouthshire* (1781), H.P. Wyndham, recounting his experiences of 1774, wrote: 'Notwithstanding this the Welsh tour has been hitherto strangely neglected, for while the English roads are crowded with travelling parties of pleasure, the Welsh are so rarely visited that the author did not meet with a single party during his six weeks' journey through Wales.' He accounts for this by stating that it was owing to the prevailing prejudices that '. . . the Welsh roads are impracticable, the inns intolerable, and the people insolent and brutish' – prejudices which, he states, have no basis in fact. Pennant's *Tours in Wales*, published in 1781, is full of descriptions of the difficulties of travelling in the region. He described the Nant Ffrancon Valley as 'the most dreadful horse-path in Wales' and the Llanberis Valley as 'a succession of stony steps'. Things are different now.

YORK Four Days Stage-Coach.

Begins on Friday *the 12th of* April 1706.

ALL that are defirous to pafs from *London* to *York,* or from *York* to *London* or any other Place on that Road; Let them Repair to the *Black Swan* in *Holbourn* m *London* and to the *Black Swan* in *Coney-street* in *York*

At both which Places they may be received m a Stage Coach every *Monday, Wednefday* and *Friday,* which performs the whole Journey in Four Days, (*if God permits.*) And fets forth at Five in the Morning.

And returns from *York* to *Stamford* in two days, and from *Stamford* by *Huntington* to *London* in two days more. And the like Stages on their return.

Allowing each Paffenger 14l. a eight, and all above 3d. a Pound

Performed By { Benjamin *Kingman* } Henry *Harrifon.* { Walter *Bayne's,*

Alfo this gives Notice that Newcaftle Stage Coach, fets out from York, every Monday, and Friday, and from Newcaftle every Monday, and Friday.

Roed; in pt. 05-00. of Mr. Bodmyford for 5
for Monday the 3 of June 1706

Preserved mail coach at Tyn-Y-Coed Hotel, Capel Curig on the A5 road. The first straight Roman roads lasted for nearly 2,000 years before the next great road builder set to work to remedy what had been essentially two millennia of neglect. The link between London and Holyhead for the Irish Mail was the driving force which brought about the engineering magnificence of the 'Colossus of Roads' Thomas Telford. Work began on the A5 road in 1815 and it was completed in 1829 at a cost of £1,000 per mile. Before this, broad-wheeled wagons pulled by a team of eight horses travelled at an average speed of 2 mph. In 1768 the Liverpool *Flying Machine* covered 206 miles in three days.

The history of the Royal Mail is complicated, but the replacement of postboys on single horses by mail coaches is the development that is of interest. In 1808 the Irish Mail coaches to Bangor were re-routed through Betws y Coed. Later, Telford's road led to a great increase of stage and mail coach traffic through North Wales. In 1835 there were 700 mail coaches on the roads of Britain covering some 12,000 miles of the country each night. The coaches' 'yards of tin' blown to warn the toll keepers to open the gates in good time were heard along the A5 at the toll gates which still stand close to the main road throughout North Wales.

A typical coaching notice from the early eighteenth century.

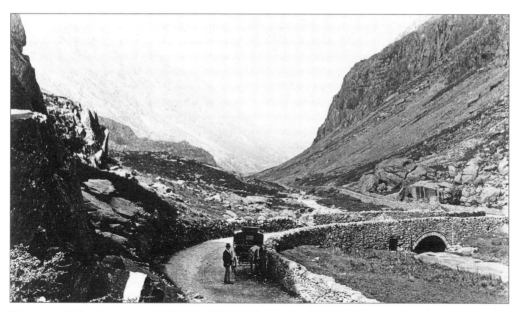

The pass of Llanberis is one of the wildest valleys in Wales, a narrow V-shaped defile set deep between towering walls of black rock. It is almost blocked by fallen boulders and debris. It is easy to see what the pass was like before the road was built: forbidding and almost impenetrable. The present road was constructed in 1832 at a cost of £3,308. Midway up the valley near a bridge (Pont y Cromlech) is an enormous rock fragment, which has the appearance of an ancient cromlech. Beneath this natural capstone an old woman named Hetty was supposed to have lived when tending her cattle, sheep and goats in the valley, hence its other name, Ynys Hetty (Hetty's Island).

The top photograph is by Bedford and shows his coach and attendant in the pass, while in the photograph below a feature of the pass is apparent; this is the 'Lady of Snowdon' whose face can be seen at the top middle right of the picture, in the cwm.

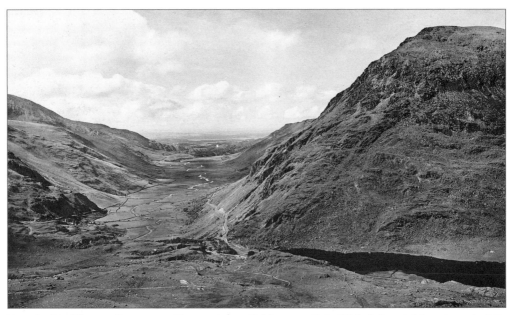

Described by Thomas Pennant as 'the most dreadful horse-path in Wales', the striking characteristic of the Nant Ffrancon Valley is its obvious glacial origin. The nearly flat bottom, through which runs the River Ogwen, is bounded on both sides by the rocky slopes of the Glydderau and Elidirs. Gouges and scratches on the mountain flanks mark the progress of the earth-shaping ice. This wildly impressive valley was possibly named after Adam de Francton who slew Llewelyn ap Grufydd in 1282, but there are several other suggested origins of the name, including 'Valley of the Beavers'. The 'dreadful horse-path' was made into a good road by Lord Penrhyn during 1790–1. This was the 'old road', traces of which can still be seen along the western side of the valley. In 1800 the road was continued to Capel Curig, where Lord Penrhyn built an inn. In 1802 the Capel Curig turnpike trust built a road which traversed the eastern side of the valley on a route practically the same as the existing road. The present road, the A5, was engineered by Thomas Telford in 1815–29 and crosses the lower slopes of Pen y Ole Wen (3,211 ft), which towers above it like the ruins of a gigantic castle.

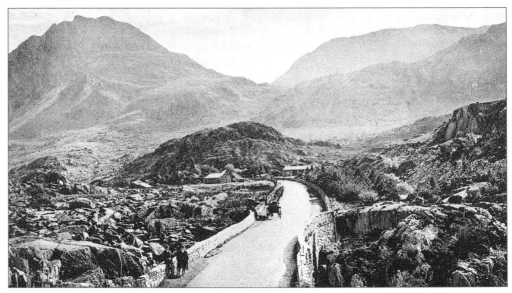

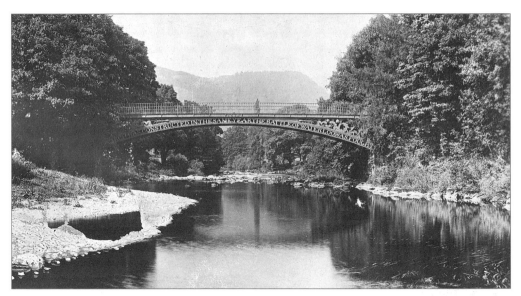

Telford completed his single-span bridge at Betws y Coed in 1817. The bridge was cast by William Hazeldine and is known as the 'Waterloo Bridge'. There is a proud inscription on the bridge, which states, 'This arch was constructed in the same year as the Battle of Waterloo was fought.' Over this bridge mail coaches were able to pass with speed and unparalleled safety to Bangor. There the road stopped because of the intervention of another major problem – the Menai Strait.

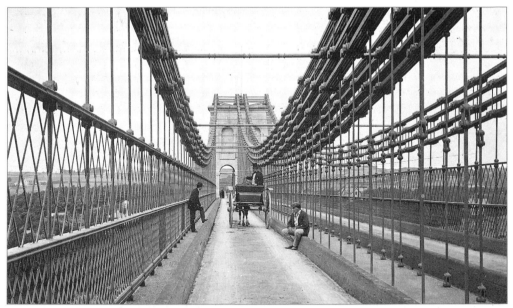

Telford's greatest single achievement in the construction of the highway was the bridging of the Menai Strait with the now world-famous suspension bridge. This, the largest bridge in Britain at the time, and of national importance, was opened with very little ceremony on 30 January 1826. Telford himself said, 'At half-past one o'clock the London Mail Coach first passed over the estuary at the level of a hundred feet above the tideway, which heretofore has presented a decisive obstruction to travellers.' David Davies drove the coach, and the guard was William Read. The mail coach superintendent was Mr Akar, and as many onlookers as possible clambered aboard on the inaugural journey through the stormy darkness.

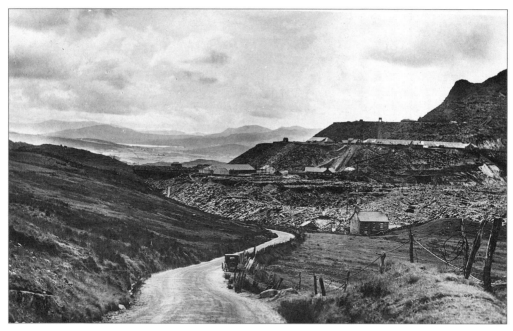

The road to Blaenau Ffestiniog was the last major road and pass to be completed in North Wales. It now carries the main A470, the Llandudno–Cardiff trunk road. John Greaves, a slate quarry owner of Blaenau Ffestiniog, contributed £75 for the original opening in 1854. The Porthmadog–Betws y Coed turnpike trust took over the road in 1864 and built the existing bridges, toll-houses, and slate milestones. It was named the 'Crimea Pass'. This is a wild pass with spectacular views over the mountain until it plunges steeply into the slate tips of the town of Blaenau Ffestiniog. The origin of the name Crimea Pass has two suggested sources. The most acceptable is that it was named after the most significant historical event of the time, the Crimean War. The other explanation is that a small inn existed on the pass, and this was frequented by the construction workers, who 'in their cups' would settle their differences without recourse to mediation, the bloody battles giving rise to the name.

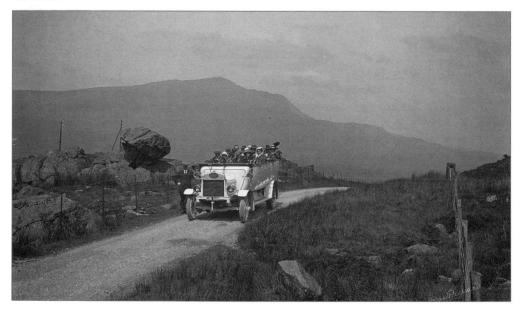

Aberglaslyn Pass is visited by many thousands of visitors each year. It is known affectionately as the 'Hanging Gardens of Wales'. The bridge outside the village of Beddgelert was at one time at the head of the estuary, and the village was a thriving port with a boat-building industry. The construction of Madock's Cob at Porthmadog effectively closed the area off from the sea. The top photograph by Francis Bedford is particularly interesting as it shows the remains of the turnpike gates; the toll cottage is to the left. The first turnpike act in Caernarfon was created in 1768, and roads were opened and maintained by toll fees throughout the country. The road from Capel Curig to Beddgelert was one such, and ran through some of the most beautiful scenery in Wales. Below, at a later date, *c.* 1918, a motor charabanc has stopped on Pont Aberglaslyn; mass tourism is arriving.

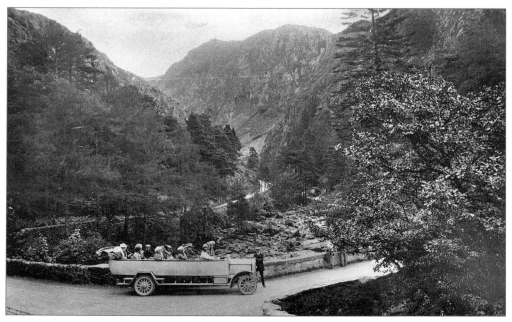

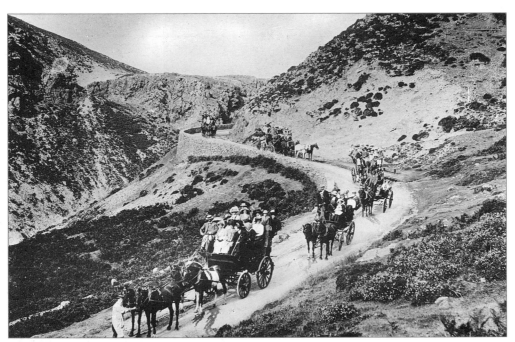

Six horse-drawn vehicles of varying sizes on the Sychnant Pass are shown in the above photograph, taken at the turn of the nineteenth century; holidaymakers from the Penmaenmawr coast are striking inland to get a closer look at the mountain peaks. Nineteen horses and fifteen or so drivers and hostlers represent quite a substantial amount of employment in the area. The picture below, *c.* 1900, shows the assembled staff of the Merioneth Carriage Works at Dolgellau. Work is provided for seventeen men and boys, a lot for such a small town. Horse transport was a labour-intensive way of moving people and goods from one place to another.

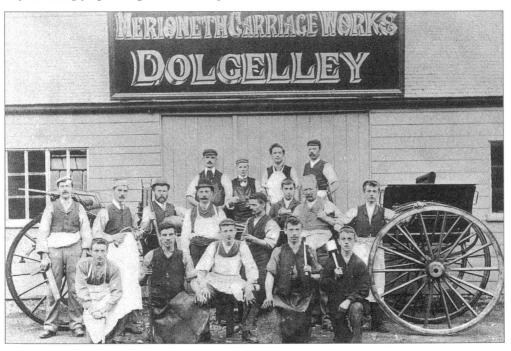

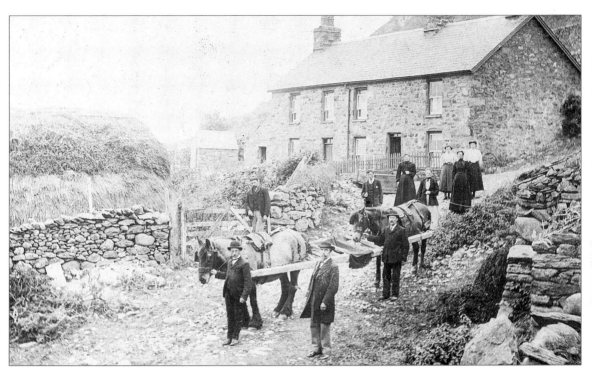

This extraordinary photograph shows a funeral cortège at a remote farmhouse in Abergynolwyn, *c*. 1910. Many Welsh farms were in such inaccessible places that a wheeled cart could not reach them. Coffins had to be carried down by bearers or, as here, on an 'elor feirch', a two-horsed bier. This was a stretcher with extremely long handles (17 ft) with a horse harnessed at either end and the coffin strapped in the centre. The photograph below shows an 'elor feirch' at the isolated church of Llangelynin, *c*. 1910. Only two of these biers still exist, on display in remote churches in Merionethshire.

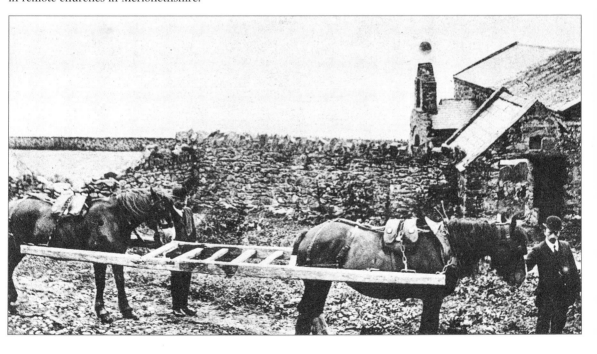

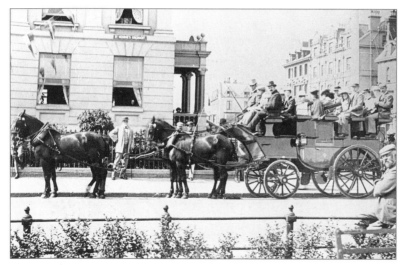

The hotels in the resorts of North Wales offered coach rides into Snowdonia as part of their attractions. These 'four in hand' trips to the Swallow Falls and beyond in coaches with special names were very popular. This photograph shows a coach leaving Llandudno promenade on such a jaunt at the turn of the nineteenth century. It could be 'The Rocket' or the 'Old Times' or 'The Prince of Wales'. This journey of perhaps three hours cost 7s. The major hotels of Betws y Coed provided as many as seventy horses and a variety of horse-drawn conveyances, and competition for custom was keen.

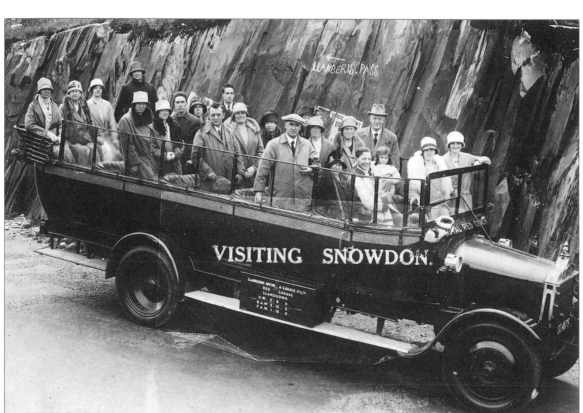

The internal combustion engine in the early years of the twentieth century led to the development of motor coaches. The 'White Rose' company of Brookes Brothers, Rhyl, and 'The Royal Red' of Llandudno, among others, began to run charabanc trips into the hills in about 1914. They could carry as many as thirty passengers on short excursions or, with hotel arrangements, on extended week-long holidays. Omnibus companies sprang up in most of the towns in the vicinity of Snowdonia providing a network of tours in both the mountain and coastal regions. The development of pneumatic tyres, and tarred road surfaces provided relief, for which 'there was much thanks'. Here, the Royal Red omnibus has stopped for the obligatory photograph on its way into Llanberis.

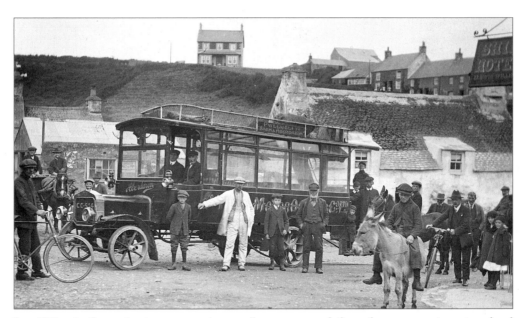

In addition to the major tour companies, smaller garages and the railway companies set up local bus services. The railways used the local buses to feed passengers into their railway system. The local service is seen here at the remote end of the Lleyn Peninsula at Aberdaron; the bus is drawn up outside the Ship Hotel. The number of people attracted by the occasion suggests that this photograph may have been taken at the inauguration of the service. The bus greatly enhanced the lives and widened the horizons of the local populace, many of whom had hardly left the confines of the village before its introduction.

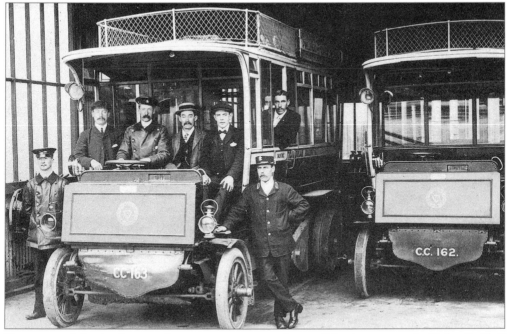

The garage of the Cambrian Railway Company operated a small local service in the Nefyn–Pwllheli area. The driver is Tom Jones, who appears on several photographs of the time. He was killed when his bus went out of control on Bodfaen Road on 5 October 1916.

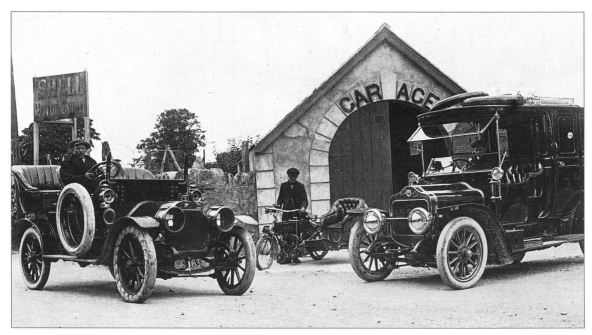

The superb photograph above shows clearly the incursion of the motor car into the area just before the First World War. The garage is located at Llanrug near Caernarfon; the open-topped car is a 12-hp Star built in 1908 at Wolverhampton. The closed car was made in Belgium in 1908/09 and is a Minerva. The motorcycle combination is probably a 1906 NSU; the luxuriously padded sidecar must have provided a hair-raising drive. The car of the common man, the one that started it all, is shown below. This is a Model T Ford in the main street of Groeslon near Caernarfon, probably in the early 1920s.

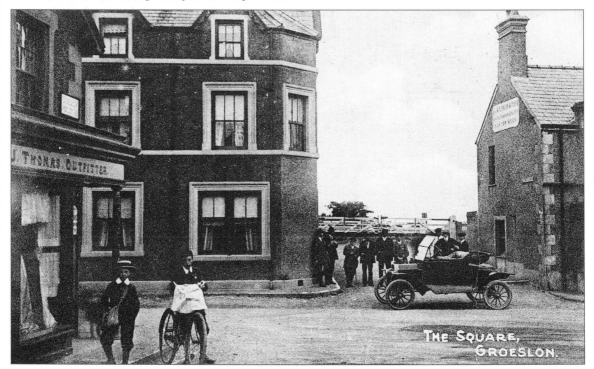

MOUNTAINS & LAKES

Tryfan. 'The first of a chain on the left was a huge lumpy hill with a precipice towards the road probably three hundred feet high.' This is not the best description of the magnificent Tryfan ever written, but it is the one that George Borrow wrote in 1862 when describing his walk from Capel Curig to Bangor. This mountain seen from the road is one of the finest sights in Wales. Unlike the majority of hills in Britain, it looks, and is, a genuine mountain peak, built upon rocky buttresses with a ragged edge and a crown of 'Adam and Eve', two upended rocks with a gap between them of 30 in. The foolhardy stride across this gap, in order to become 'Freemen of Tryfan'. This is one of the most terrifying things the author has ever done, since a missed step means a fall of perhaps 2,000 ft into Cwm Tryfan.

The precipice referred to by Borrow was probably the Milestone buttress standing above the 10-mile marker from Bangor. This is a happy hunting ground for climbers; the whole mountain is immensely popular. On high days and holidays it is as crowded as Piccadilly Circus, and indeed one ledge, the confluence of several routes, is called just that. Its popularity led to it having a 'slummy' summit with attendant litter. It even boasted, at one time, of having a colony of mice scavenging on the food left by walkers and climbers, surely the highest resident mice in Great Britain at 3,010 ft.

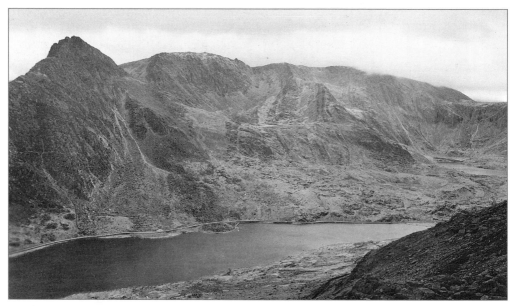

The Glydderau. The top photograph shows Tryfan on the left with the exciting Glydderau to the right. Glyder Fach (Little Pile) appears deceptively higher than Glyder Fawr (Big Pile). Glyder Fach is more imposing than its bigger brother, with a summit consisting of a haphazard jumble of rocks cast by a giant hand. The upturned Castell y Gwynt (Castle of the Winds) produces eerie noises from its organ-like windswept columns. Near the top is the Cantilever, a rock which everyone has to walk along; it is irresistible (see below). In 1781 Pennant said, 'The tops are frequently crowned in the strangest manner with other stones lying on them horizontally. One was about twenty-five feet long and six broad. I climbed up and on stamping with my foot felt a strong tremulous motion from end to end.' On the slopes of both mountains there are prodigious rock climbing cliffs of great severity: Carreg Wastad, Clogwyn y Grochan, Craig Ddu, Craig Nant Peris, and Dinas Cromlech, one of the first cliffs to be designated 'Exceptionally Severe'. Both mountains demand respect when walking, especially in winter, and in mist whatever the season.

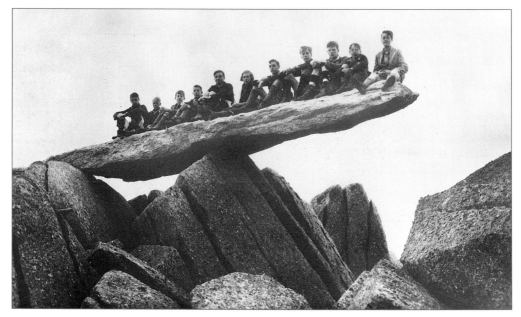

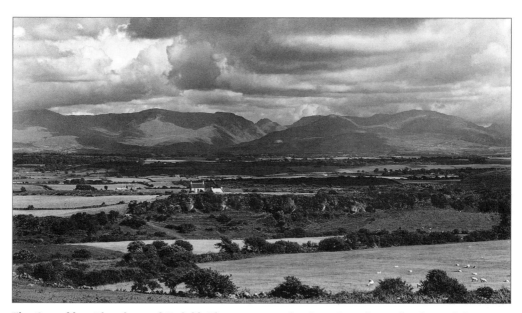

The Carneddau: Llywelyn and Dafydd. These are second only to Snowdon in height, and they cover a large area from Conway Valley in the east to Nant Ffrancon in the west, and from the sea at Penmaenmawr to Llyn Ogwen in the south. They are mountains of vast grassy bulk, and only in the lower Ogwen Valley do they look impressive. The summit of Llywelyn is composed of dolorite rock which is erosion resistant and so adds a slice of character to the range. Whether it is named after Llywelyn the Great or Llywelyn ap Gruffydd ap Llywelyn (Wales's last native prince) is not absolutely clear, but the money usually goes on 'the Great'. He is reputed to have used the mountains a great deal as an observation post. Carnedd Dafydd is named after the younger son of Llywelyn the Great and is slightly lower than Carnedd Llywelyn, though it is still one of the four 3,000-ft summits. The best route for both mountains is probably from Pen yr Ole Wen. There are powerful rock climbing areas in the Carneddau, for example Craig yr Ysfa, and Ysgolion Duon (the Black Ladders), called by Pennant 'the most horrid precipice that thought can conceive'. It is easy to get lost in this range in misty weather so keep an eye out for cairns which mark the peaks in the range, and give the range its name.

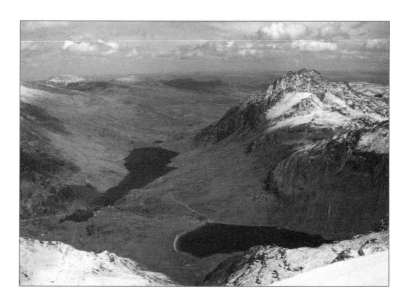

The Carneddau are in the top left of the photograph, beyond Llyn Ogwen. Snow-capped Tryfan is seen in the top right.

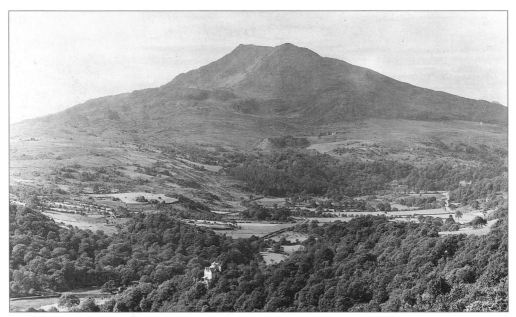

Moel Siabod. Between Betws y Coed and Capel Curig, and to the left of the A5, the beautiful mountain of Moel Siabod (the Bare Hill of the Abbot) comes into view. Siabod is 2,860 ft high, but looks higher, The summit has a habit of being just a little bit further on when you think you are about to reach it. On the summit is a large protective cairn which, it is believed, was used to pen the horses which brought up the early travellers. Belying its benign aspect the mountain is dangerous, especially at night or in mist; Robert Southey, the poet, was lost on its slopes and had to spend an uncomfortable night.

G. Winthrop Young says, 'The thrill of a mountain first seen or of a first climb attempted, remains for each newcomer a unique sensation.' This mountain holds this sentiment for the author, as it is the first he ever climbed, and the one that gave him the taste for it.

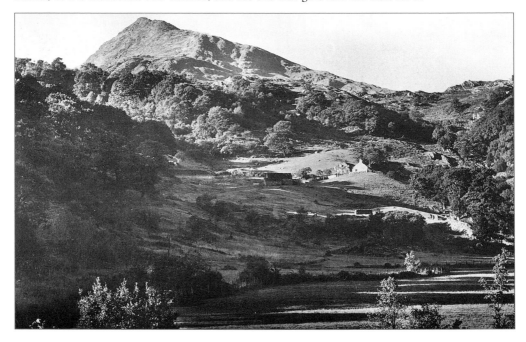

Moel Hebog. This magnificent mountain stands over the village of Beddgelert at a height of 2,569 ft. It is an excellent day's mountain walk with exceptional views from its summit, but offers few rock climbing challenges. It has a significance in Welsh history as it provided an escape route for Owain Glyndwr as he fled from the English. His escape is yet another record of one of the first rock climbs (Glyndwr's Ladder) in history, as it occurred in about 1406. He made his way over Hebog to Moel Yr Ogof (the Hill of the Cave) at the end of Cwm Meillionen, and he hid in the cave for six months. The prior of Beddgelert is reputed to have organised provisions during his stay. Glyndwr's insurrection ended in defeat but still lives in the minds of Welshmen. The lower slopes of the mountain towards Llyn Cwellyn are unfortunately covered by the Forestry Commission's enveloping blanket.

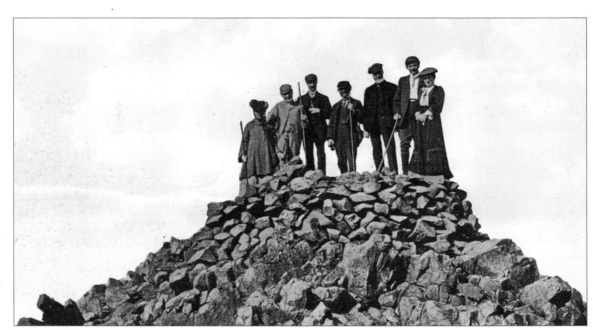

Cader Idris. 'We looked at them indeed with astonishment for their rugged tops and immense height of them.' Thus Defoe described the Cader Idris range of mountains. He noted further that 'some are of the opinion that Kader Idricks [sic] is the highest mountain in Wales'. The range runs parallel to the Mawddach estuary, from Barmouth to Dolgellau. It is said, 'the walls of Dolgellau are three miles high'. The name of the main peak means 'the chair of Idris', Idris being the obligatory giant of the district. Giant legends abound because they possess attributes valued by the primitive societies who talk of them, i.e. great size, and above all, physical strength. Idris's chair is 2,927 ft high.

In 1888 Owen Glynne Jones (a Londoner despite his Welsh name) made a historic rock climb on Cader's cliffs.

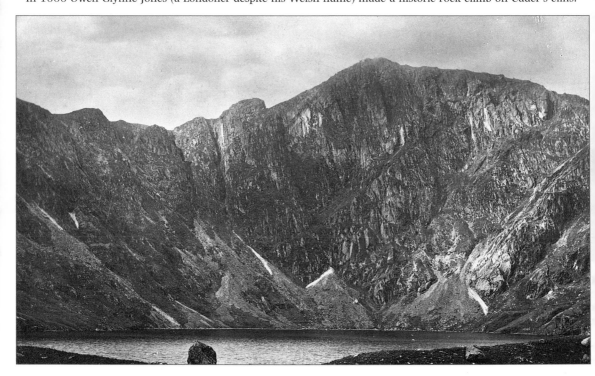

Cnicht. To the south of Snowdonia one mountain stands out with almost alpine features. This is Cnicht (the Knight), one of the eight Moelwyn mountains that exceed the height of 2,000 ft. It towers above the old mining village of Croesor and dominates the skyline around Cwm Croesor. In *Over Welsh Hills* Frank Smythe calls it 'The Welsh Matterhorn'. In 1885 the village of Croesor was the birthplace of Bob Owen, a quarryman who

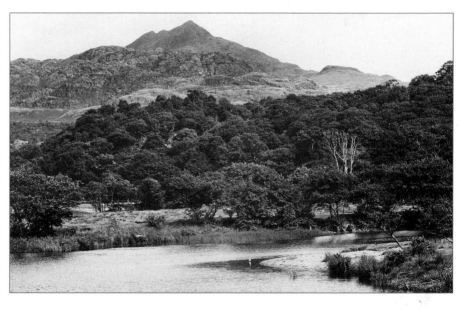

distinguished himself as a scholar and bibliophile. He left school at the age of thirteen but became a self-educated historian and genealogist. He knew the Moelwyns like the back of his hand. When he died in 1962 his library of 47,000 books was bequeathed to the National Library of Wales at Aberystwyth.

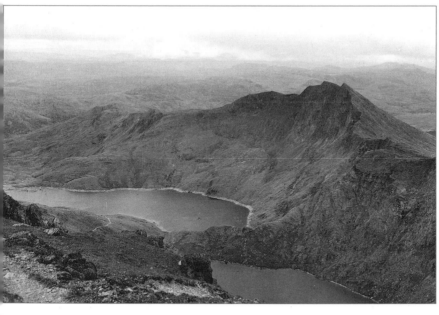

The lakes closest to the Snowdon massif are generally the better known in the national park. The brooding menace of Llyn Glaslyn under the central peak seems to have particular fascination for the traveller. It was formed as the result of glacial action: a glacier scooped out Cwm Dyli with a grinding determination before turning to scour out Nant Gwynant. The lake is reached by walking the Miners' Track. It is one of the highest lakes in Wales at just under 2,000 ft, and is less than a quarter of a mile long.

Its bottomless reputation comes to grief at 127 ft. It was once known as Llyn Ffynon y Las (Lake of the Blue Spring). They say that no bird will fly over it, it is the home of devils and aquatic hobgoblins, it never freezes, and no fish can live in it. The turquoise water is coloured by the copper residues washed in from the new defunct mines on Glaslyn's slopes.

If you are there at night, watch out for the legendary Afangc, a nasty beaver-like creature large enough to require the strength of two oxen to drag it over Siabod and Bwlch Rhiw yr Ychain (Pass of the Oxen's Slope) from Betws y Coed, where it was creating mayhem in the Beaver Pool.

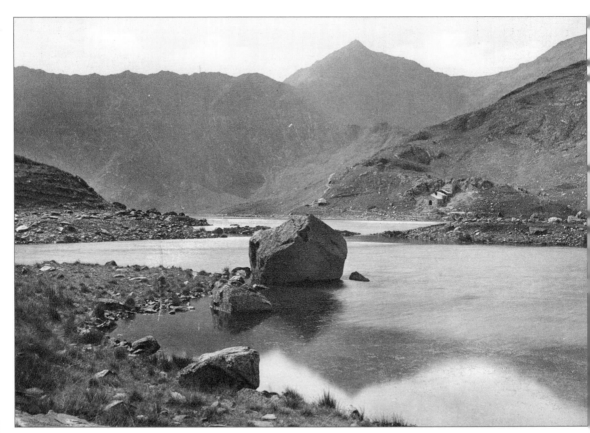

Llydaw. The waters of Glaslyn tumble and plunge into Llyn Llydaw. At 1,455 ft Llyn Llydaw is in many ways redolent of the industrial past of this wild area. The ruins of a rock-crushing mill lie on its banks. A miners' track crosses its eastern end; a causeway constructed in 1853 lowered the lake surface to facilitate the transport of copper ore. There was once a barracks on its shores to house the men from Llanberis who lived there during the working week. The stone foundations of an overhead cable system, which carried buckets of ore, can still be seen. And yet this lake remains very beautiful. It is larger than Glaslyn and deeper by some 63 ft. Some affirm that this is the burial place of King Arthur, after his comeuppance on Bwlch y Saethau. Excalibur flashed across its surface before being caught by the emerging hand. A dug-out canoe found when the lake was lowered was either rowed by the three 'fayre ladyes', or is evidence of a lake-dwelling community way back in the mists of time. Below Llydaw in Cwm Dyli is the smallest of the group of three, Llyn Teryn (the Lake of the Monarch). The waters of Llyn Llydaw are captured in an ugly pipe, and taken to drive generators in the Cwm Dyli Power Station in Nant Gwynant, a piece of industrialisation which jars on most people's sensitivities.

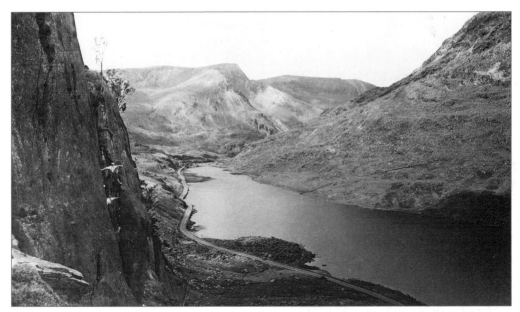

Llyn Ogwen lies alongside Telford's A5 out of Capel Curig. Tryfan appears to rise out of its waves and dominates the valley on the left. The lake sheds its waters over Ogwen Falls, one of Wales's better known waterfalls, and tumbles into Nant Ffrancon. It is one of the shallowest of Welsh lakes its maximum depth being 10 ft, and it averages a depth of 6 ft. It was once much deeper but is gradually being silted up, a process that has raised most of the valley floors in the area. The lake was originally called Ogfanw (the Young Pig). It is a stretch of water favourably regarded by anglers.

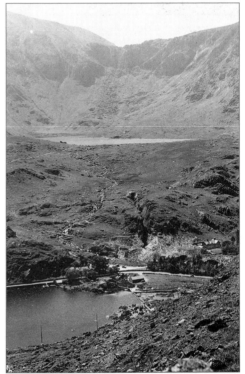

Llyn Idwal. This magnificent lake in its awe-inspiring setting is half a mile wide with a greatest depth of 36 ft. It is in a hollow spooned out by glacial action, and is held in place by a barrier of glacial discard. One of the lateral moraines on its western shore is said to cover the remains of the giant, Idwal, who may have given his name to the area, though, as usual, there are other possible explanations.

No birds fly over the lake, except those who have not heard of the ban, and those who have heard of it but disregard it. The area is seething with school parties in the season and amateur geologists are a common species, hand in hand with botanists. Fledgling climbers congregate in the area of Idwal Slabs, and the Devil from his Kitchen scowls over it. The photograph shows Llyn Idwal in the middle distance, with Llyn Ogwen below and Ogwen and Idwal cottages.

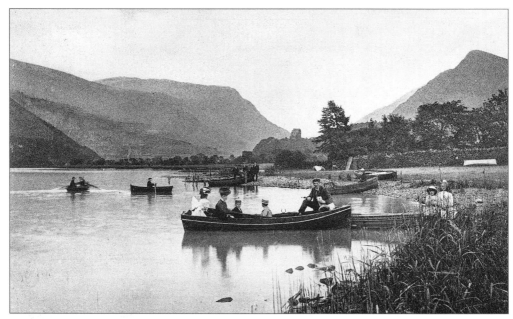

Llyn Padarn (above), the larger of the two lakes at Llanberis, was a very commercial waterway during the Industrial Revolution with mining and quarrying activity going on in its vicinity. Margaret French dominated the lakes area in the mid-eighteenth century; she was a boat builder, and carried copper ore from the Nant Peris mines. She was also a great hunter and a prodigious wrestler. Following the glaciation which created the Gwastadnant (the smooth levelled valley) the two lakes were one; alluvial drifting and silting with glacial debris eventually sealed the lakes in and separated them. Llyn Peris (below) is the deeper of the two lakes by some 24 ft at 114 ft. This lake was given over to the Central Electricity Generating Board, and amid a storm of protest became a pumped storage unit working in conjunction with Llyn Marchlyn Mawr (see p. 143). On the far side the lake boundary is scarred by the remains of the disused slate quarries, which have sliced through the mountainside.

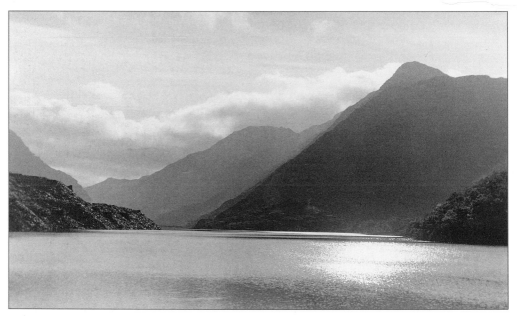

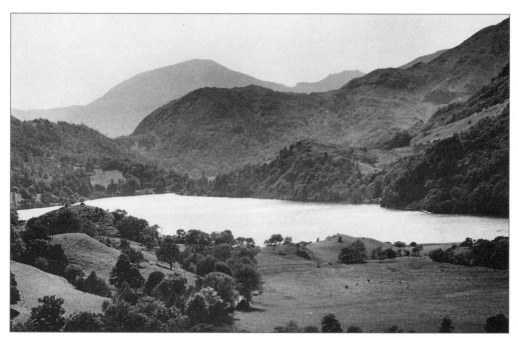

Nant Gwynant is a 7-mile long valley of great beauty. Llyn Gwynant (above) is 3 miles from the head of the valley, and 1½ miles away is Llyn Dinas (below). The area is usually packed with tourists during the summer season so is perhaps seen at its best in the autumn and winter. There is a mess of mythology associated with the area around Dinas Emrys involving the miscreant Vortigern, Myrrddin Emrys (Merlin of the Arthurian saga), Aurelius Ambrosius, and a tangled web of intrigue that would require too much explanation to fit here. The waters from these two beautiful lakes course through Aberglaslyn and Beddgelert to the sea at Porthmadog.

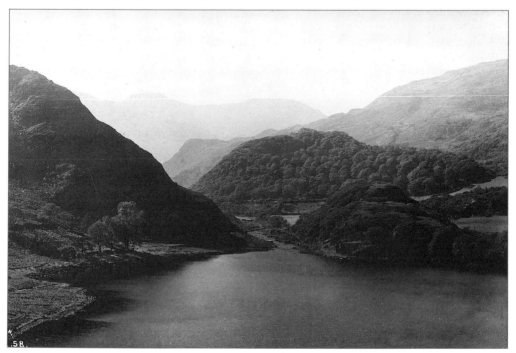

Bala Lake was privately owned until 1944 when it reverted to the Treasury in payment of death duties. It is a wonderfully calming stretch of water best seen in autumn or early spring before the hordes of tourists arrive. It is 4½ miles long and 1 mile wide. As well as the normal fish species it contains a fish unique to itself, 'The Gwyniad', an Alpine fish (salmonid, genus giregonus). Pennant refers to the fish: it will not rise to bait and has to be netted. On average it weights ½ lb but fish of 2 lb in weight have been caught. The River Dee flows through the lake and in doing so it greatly increases in size.

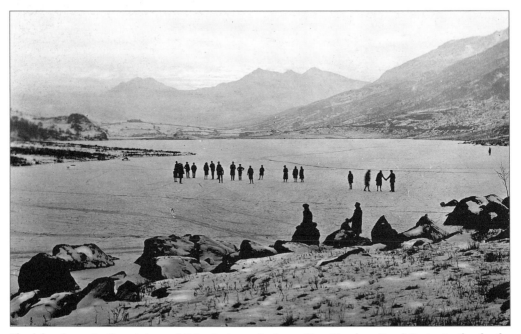

The lakes freeze in the winter and this photograph shows Llyn Mymbyr, Capel Curig, in the depths of winter. This lake is usually dotted with canoes as part of the watersports instruction offered by Plas Y Brenin Outdoor Centre.

PLACES OF INTEREST

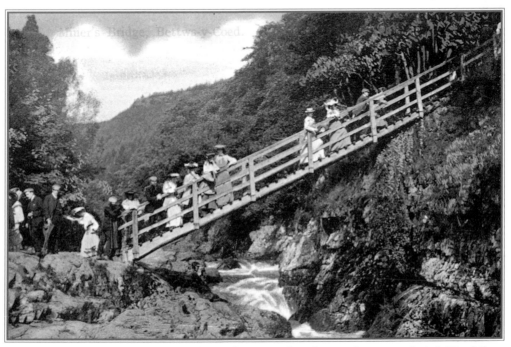

On the A5 out of Betws y Coed towards Capel Curig and in the area known as Artist's Wood there is a bridge over the Llugwy known as Miner's Bridge; this is the oldest crossing of the Llugwy. It was originally a crossing associated with Sarn Helen, a Roman road to Dolwyddelan. It later became a short cut for miners living in Pentre Du who worked in the lead and zinc mines above the village. There is no mining activity now; the last mine in Betws y Coed closed in 1904, while other mines remained open into the 1930s and beyond.

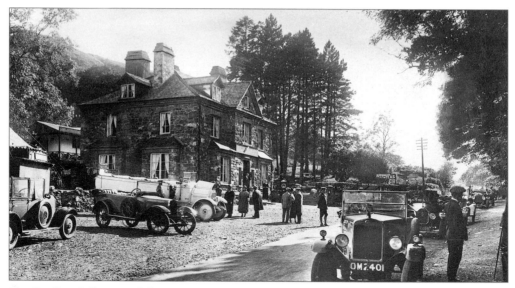

The Swallow Falls. One of the most frequently visited sites in the Snowdonia National Park lies a couple of miles from Betws y Coed, and may be visited by those willing to pay a fee and pass through a turnstile. These are Rhaeadr y Wennol, the Swallow Falls, where the Llugwy tumbles 60 ft to join the River Conwy. It is said that the tormented spirit of Sir John Wynne of Gwydyr is being cleansed in the pool below the falls to atone for the life of torment and oppression he subjected his people to during the 1600s.

The real name for the falls should be the 'Foaming Falls' but, because of a mistranslation of the original Welsh name 'rhaeadr ewynnol' as 'rhaeadr y wennol', 'Swallow Falls' it has been since before Pennant came along in 1781.

It is of interest that George Borrow had to pay a fee to a guide when he visited the falls in 1854: nothing changes.

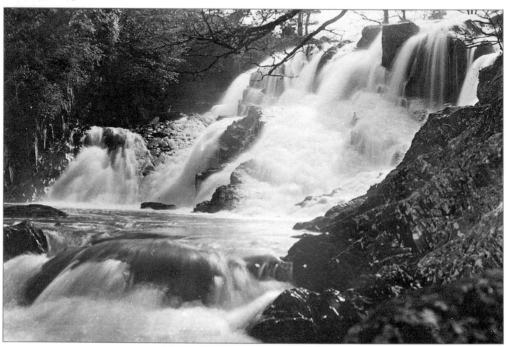

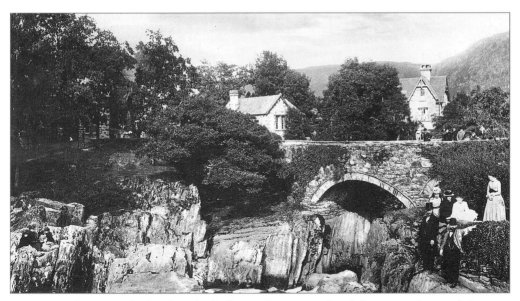

Betws y Coed is certainly the place for bridges – there are eight of them in and around the area. The village developed around Ponty y Pair (Bridge of the Cauldron, above), said to have been built by Inigo Jones, but more likely by Howell, the stonemason from Bala, in the fifteenth century. The river tosses, tumbles and boils as if in a cauldron so the origin of the name is obvious. Not far from here, the Rivers Conwy and Llugwy meet and flow to the sea down the Conwy Valley.

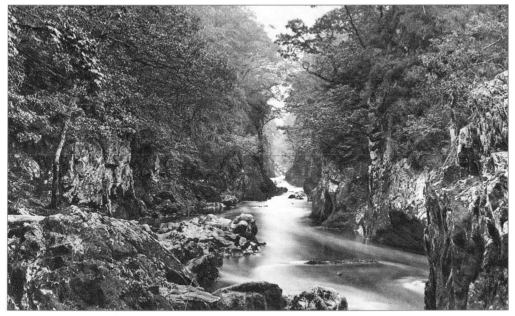

The Fairy Glen lies a mile south of Betws y Coed, and you have to turn right off the A5 towards Corwen to get to this enchanting place. A placid river pool is surrounded by sculpted rocks and trees, and resembles an illustration for a fairy story. Y Tylwyth Teg (the Fair Family) live here, some small enough to scuttle into a flower cup to escape detection, others as big as adult humans. Most of them are nice enough, though predisposed to mischief. Do not be tempted to join in their dancing because you will not escape for a year and a day, and don't be tempted to marry a fairy for it will end in tears.

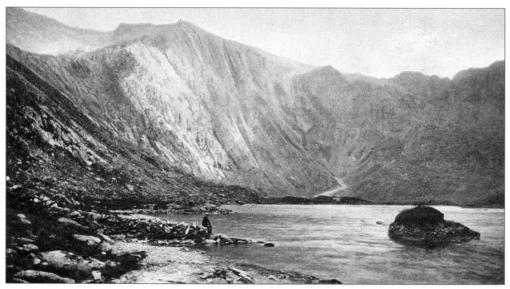

Cwm Idwal and the Devil's Kitchen. Cwm Idwal is one of the most remarkable of Welsh cwms. The valleys hanging above the scoured rock surfaces of its bowl offer striking evidence of the glacial activity that Darwin and Professor Adam Sedgwick failed to notice on their visit of 1831. Darwin said later, 'We spent many hours in Cwm Idwal examining the rocks with extreme care . . . but neither of us saw a trace of the wonderful glacial phenomena all around us.' In the right conditions this cwm and tarn hold a savage and sombre mystery, which is unrivalled anywhere in the world.

Above the cwm is an awe-inspiring cut in the cliff face known as Twll Ddu (Black Hole) or more familiarly the 'Devil's Kitchen'. Water tumbles hundreds of feet down this cleft from the plateau above. The view from the top is not recommended for the vertiginous. Pennant peered over the edge in the eighteenth century and said, 'I ventured to look down the dreadful aperture and found its horrors far from being lessened by my exalted situation.' Mariners are said to have named it after seeing the misty cauldron in the distant hills as they sailed the Menai Strait, though their reference was to the whole of Cwm Idwal, of which Twll Ddu is only a part.

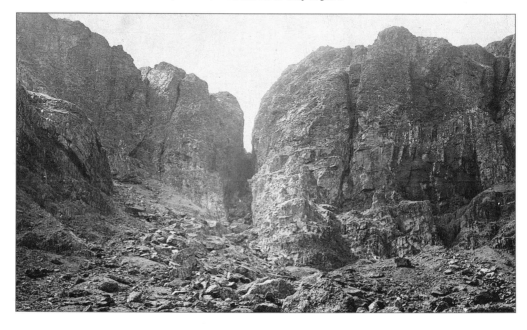

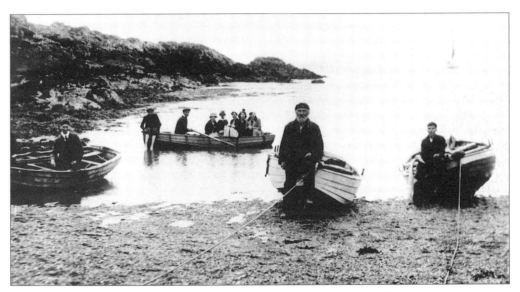

Bardsey, and the 'King of Bardsey' at the landing place, *c.* 1918. Bardsey Island is regarded as the last resting place of Merlin, who is reputed to sleep on the island in a glass case with the 'Thirteen Treasures of Britain', awaiting the reappearance of King Arthur. The island was named after a Viking, Bardr, and it is supposed to be the burial place of 20,000 saints. It is said that so numerous were the human bones discovered they were used to make fences. A Celtic sanctuary was built here in the sixth century and an Augustine monastery in the twelfth century. This gave sanctuary to the monks fleeing from a massacre at Bangor Isycoed, near Wrexham. Three pilgrimages to Bardsey equalled one to Rome. The third Baron Newborough appointed a head man to look after his interests on the island, and he was known as the 'King of Bardsey', a royal dynasty that lasted until 1926. The island once boasted a community of over 100 people but this disintegrated during the Second World War. Its lighthouse built in 1821 remains, and the island is now a bird sanctuary and ringing station.

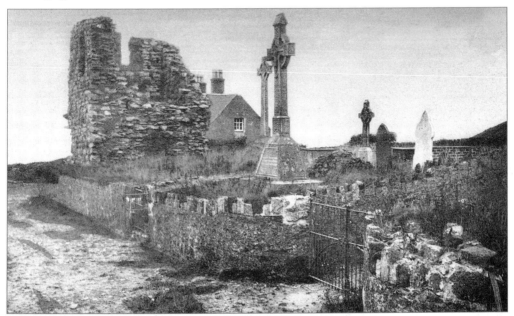

The Graveyard of the Saints, Bardsey Island.

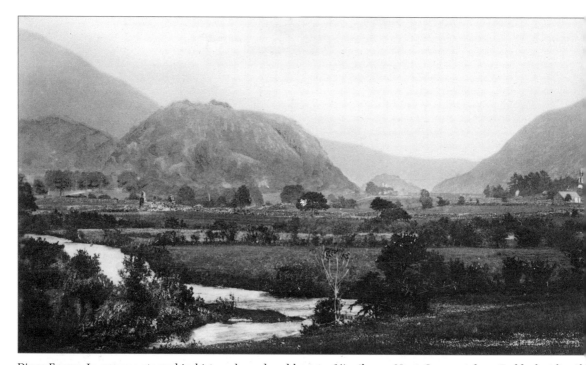

Dinas Emrys. In an area steeped in history, legend and beauty, 1½ miles up Nant Gwynant from Beddgelert lies th
detached hill known as Dinas Emrys (The fortress of Ambrosius). It is a hill of proven historical significance, a
there is evidence of Iron Age occupation and also twelfth-century castle construction. The myth is mor
interesting: Vortigern, King of Kent, is reputed to have taken refuge here after becoming singularly unpopular wit
his contemporaries for inviting the Anglo-Saxons into Britain. Difficulties with the building of his fort brought i
the wizard Ambrosius Merlinus (Merlin of Arthurian fame) whose advice led to the uncovering of two sleepin
dragons, one white and one red, who proceeded to fight. The red dragon, symbolic of Wales, eventually won, an
that is how 'Y Draig Goch' became the emblem of Wales (so it is said). Merlin's Welsh name is Myrddin Emry
Here the legends of King Arthur have their origin.

Nant Gwrtheyrn on the Lleyn Peninsula is a
cliff face at the foot of Yr Eifl, the three-forked
mountain known to the English as 'The Rivals'
It was here that Vortigern, 'the Tall', King of
Britain, jumped to his death in a stormy sea.
He arrived here after he had invited Hengist
and Horsa into his Kentish kingdom, an
invitation that was to have disastrous
repercussions for him. After his fatal leap, a
fearsome fire 'from heaven' destroyed the castl
he had built. On the central peak of Yr Eifl at
1,849 ft there is evidence of a large Iron Age
fort. Pennant visited the summit in 1781 and
wrote that it was 'the most perfect and
magnificent, as well as the most artful, of any
British post I ever beheld'. Trêr Ceiri is the
largest walled Iron Age hill fort in Great
Britain, and the remains of 150 or so circular,
oval and rectangular buildings can be seen.
Evidence has also been found of Roman
occupation.

CHAPTER SIX

CASTLES

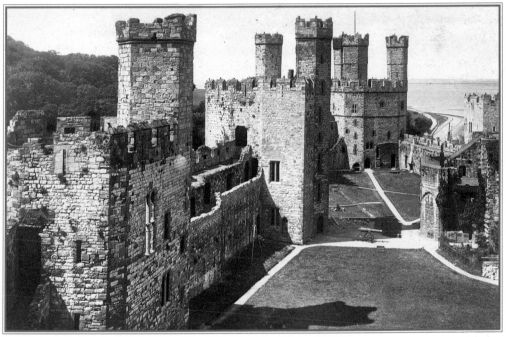

Throughout history attempts to conquer and subjugate the people of North Wales have faltered and failed in the face of insurmountable environmental obstacles. Rivers, marshes and rugged mountain terrain have weighed heavily in the favour of the indigenous population. In addition, Welsh fighting tactics of scorching the earth before retreating to the mountains, and then indulging in rapid guerrilla skirmishes, made them formidable opponents. The Romans had some success and there is evidence of their occupation dotted all over North Wales by way of roads, encampments and forts; for example, Segontium in the fields just outside the town of Caernarfon, and the Marching Camp at Pen y Gwryd. The area was attractive to the Romans largely because of its mineral wealth.

In the thirteenth century Edward I began a castle-building programme which eventually held North Wales in a clenched stone fist. In all there were seventeen castles constructed and seven of the most magnificent were built on the North Wales seaboard. From the east these were Flint, Rhuddlan, Conwy, Caenarfon, Beaumaris, Criccieth and Harlech. All of these structures were erected in an amazing flurry of activity in the last quarter of the thirteenth century. In the twelfth century two castles were built in Snowdonia by the Welsh princes; these were Dolwyddelan in the Lledr Valley, and Dolbadarn, Llanberis.

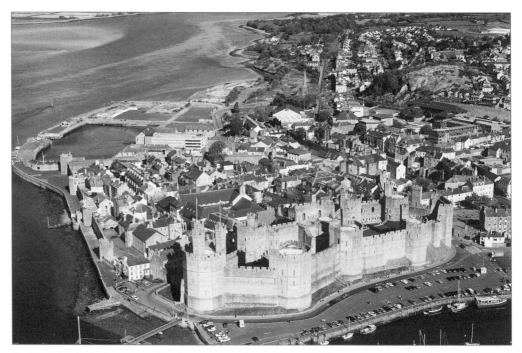

Caernarfon Castle has a special place among the castles of Wales because it is such an exceptional example of military might and splendour. The castle is the work of James of St George, Master of the King's Works in Wales. Building began in 1283 after Edward's conquest of Wales and went on for forty years. The castle was never really completed. Walter of Hereford took charge in 1294. It was built on the site of a former motte and bailey castle erected by Hugh de Lupus in Norman times. A nearby Roman settlement, Segontium, was abandoned in about AD 395.

The interior of the castle was used for important civic events and below, the townspeople have gathered to hear the proclamation of George V as King in 1910. This event took place all over the United Kingdom on this day.

Pennant described the castle as 'that most magnificent badge of our subjection'. And Dr Johnson, who was not given to fulsome praise, called it 'an edifice of stupendous majesty and strength', and so it is.

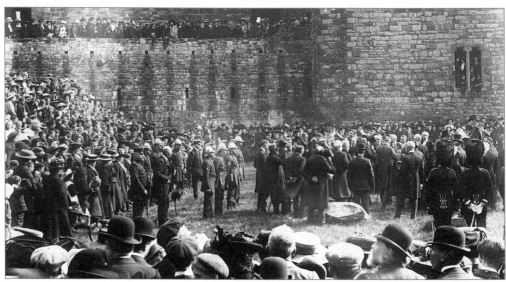

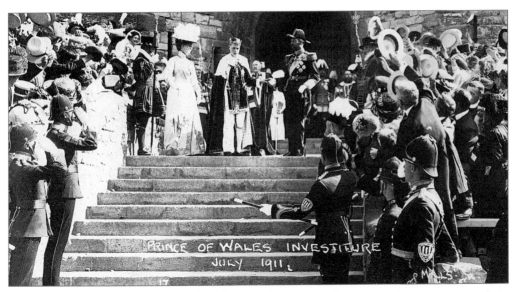

On television 500 million people watched the investiture of Charles, Prince of Wales in the castle in 1969. This was the twenty-first investiture since the first in 1301. The title 'Prince of Wales' has usually been given to the sovereign's eldest son and, it must be said, several of them have been indifferent to the honour. The photographs on this page show the investiture of Prince Edward (Edward VIII) in 1911. This was the revival of a ceremony that had lapsed for almost three hundred years. The revival had been fostered by the Bishop of St Asaph, Dr A.G. Edwards, who perceived it as an opportunity to increase the prestige of the Principality. The rituals that had last been performed at the investiture of James I were strictly adhered to in the 1911 ceremony.

When he became King, Edward generated an unprecedented amount of affection among the people of Wales. During the Depression he visited the Welsh Valleys and became visibly moved by the plight of the people. His outburst, 'Something must be done. I will do all I can to help you', forged a bond and raised expectations. But soon, alas, children were singing, 'Hark, the Herald Angels sing, Mrs Simpson's pinched our King.'

And the new King was unable to keep his promise.

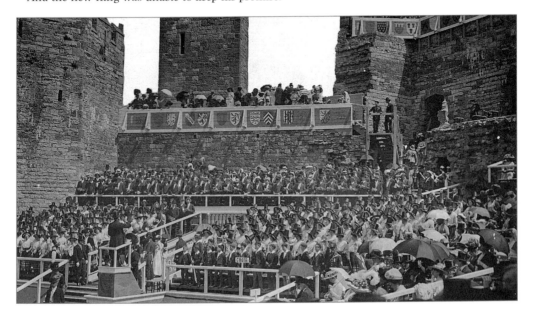

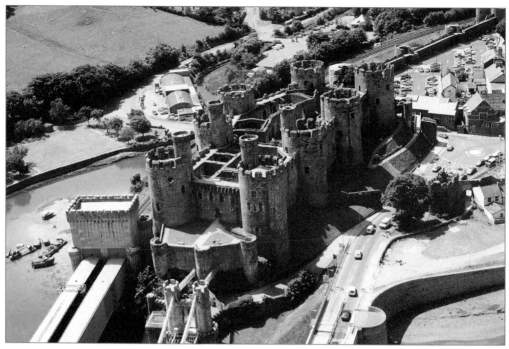

Conwy Castle was built in the very short time of four and a half years. It was started in March 1283 and finished in the autumn of 1287, and is recognised as one of the world's major achievements in military architecture. Edward imported 1,500 workers from England and France, and in charge of them was the Savoyard, James of St George, Master of the King's Works in Wales, who also built the castles at Caernarfon and Harlech. Conwy Castle cost some £13,600, the equivalent in excess of £11 million today. It has eight drum towers and was originally whitewashed. Only English people were allowed to live and work within the castle and the town walls. The Welsh lived outside and could only be farmers and shepherds. The setting and structure make this probably Europe's most perfectly preserved medieval town, and its later buildings and bridges make it an essential tourist attraction.

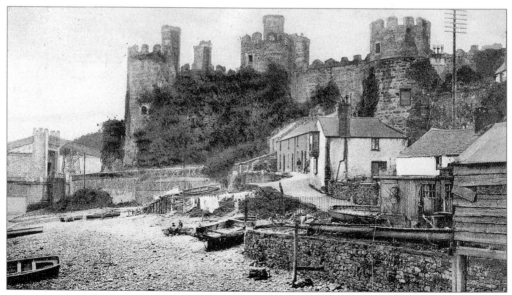

On a crag separating two huge bays stands Criccieth Castle. The site has been occupied as a fortress since the Bronze Age. Originally it was a castle occupied by Welsh princes. Part was built by Llwelyn ab Iorweth (the Great) and part by his grandson Llwelyn ap Gruffudd (the Last). Edward I captured it in 1282 and it was considerably extended and reinforced at his command in 1283. During the reign of Edward the Black Prince the castle had a distinguished constable, Sir Hywel ap Gruffydd (Sir Howel of the Battleaxe). Into Elizabethan times a charitable bowl of meat was served daily to the poor of Criccieth in front of his axe. The Welsh briefly regained control of the castle in 1404 during the reign of Henry IV when Owain Glyndwr sacked and burned it. The views of Tremadog Bay from the castle viewpoint are highly recommended, especially during summer evenings.

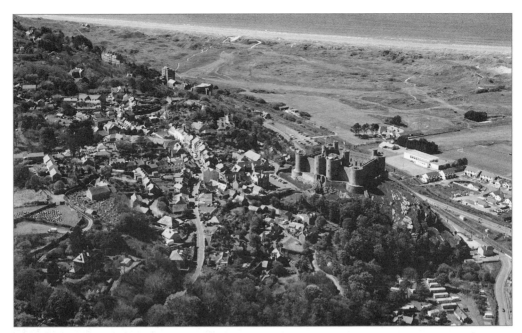

The impregnable reputation of Harlech Castle was called into question in 1404 when it was taken by the army of Owain Glyndwr, who held court there with his family for four years, until he was defeated and fled into the mountains of Snowdonia. This marked the end of Glyndwr's rebellion. It was the last bastion of the Lancastrians in Wales during the Wars of the Roses, falling after a siege of eight years. Its heroic defence is remembered in the lyrics of the famous march, 'Men of Harlech'. The building of the castle took place during Edward's second campaign (1283–9). The site occupies a perfectly symmetrical square ground plan, and is almost completely windowless. The sea has now withdrawn from the foot of the cliff on which the castle stands and now washes ashore about a mile away.

This beautiful castle stands on the foothills of the Rhinogs on a rock of grey Cambrian gritstone named by the geologists the 'Harlech Dome'. Cromwell's troops were ordered to destroy the castle, but for some reason they ignored the command; perhaps their hands were stayed by a realisation of the philistinism of such an act.

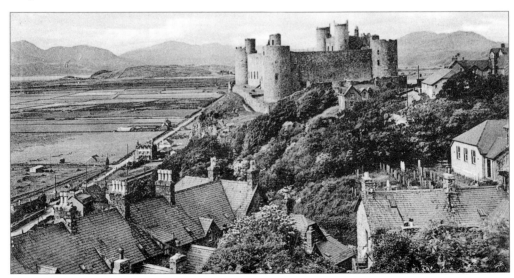

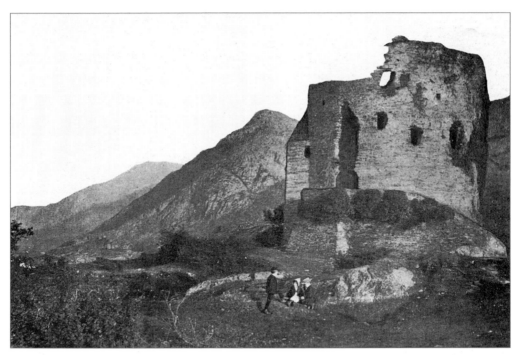

Dolbadarn Castle stands at the entrance to the Llanberis pass on a promontory separating the twin lakes. It was built by Iorwerth of the Broken Nose in the late twelfth or early thirteenth century. The tower is constructed of mortared rock and was originally capped by a conical roof. Llywelyn imprisoned his troublesome brother Owain Goch here for twenty years. Owain Glyndwr used it during the first years of the Welsh uprising of 1400 as a prison for Lord Gray of Ruthin, whose treachery had ignited the fire which flamed the rebellion. The castle had three towers originally. It has been an inspiration for artists throughout the years, and Turner's magnificent oil painting is perhaps the most well known.

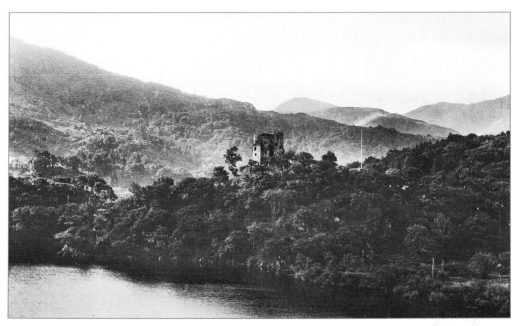

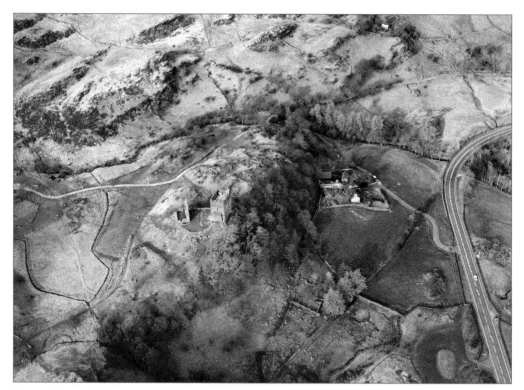

The square isolated tower of Dolwyddelan Castle stands on a hillock at the base of Moel Siabod near the village of Dolwyddelan in the Lledr Valley. The castle was probably built in 1170 by a Welsh chieftain, Iorwerth of the Broken Nose, the father of Llywelyn ap Gruffydd, who is reputed to have been born there. More than 100 years later, in 1283, the castle was captured by Edward I who strengthened its defences. In 1282 the head of Llwelyn ap Gruffydd had been paraded through the streets of London, impaled on a spear and decorated with ivy. The castle originally consisted of two towers connected by walls enclosing a courtyard. Only one of the towers now remains. The castle is perfectly situated for guarding the medieval route from the Vale of Conwy to Ardudwy.

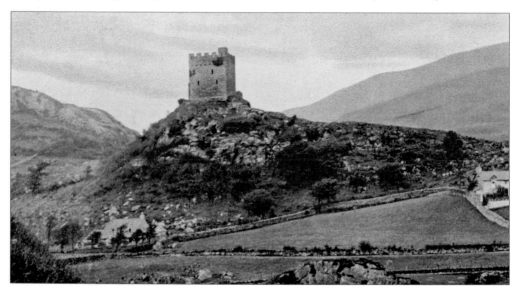

CHAPTER SEVEN
TOWNS & VILLAGES

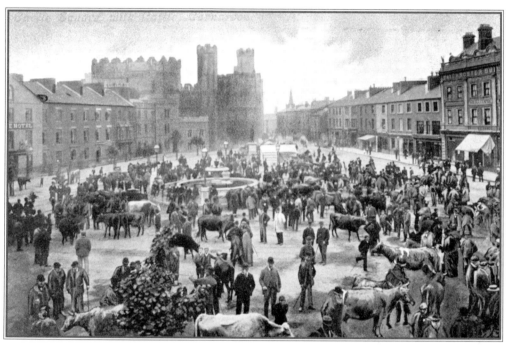

A busy cattle market scene in Castle Square before the venue was changed to the bottom of Gypsy Hill at Smithfield early in the twentieth century.

Caernarfon was considered to be the capital of Snowdonia for many years because of its combined roles as an important tourist centre and industrial port. Its greatest attraction was its castle, but it could offer the traveller hot baths and cold seawater baths before the end of the eighteenth century. There was excellent accommodation offered in a large number of well-built houses and clean, well-appointed inns. Caernarfon was the first town to set up a coach business for transporting visitors into the mountains. Many local men earned a seasonal living by acting as mountain guides. There was a regular ferry service across the Menai Strait to Anglesey. During the 1950s Caernarfon was a strong contender for becoming the capital of Wales but lost out to Cardiff; however, it is still widely regarded as being the capital of Welsh-speaking Wales.

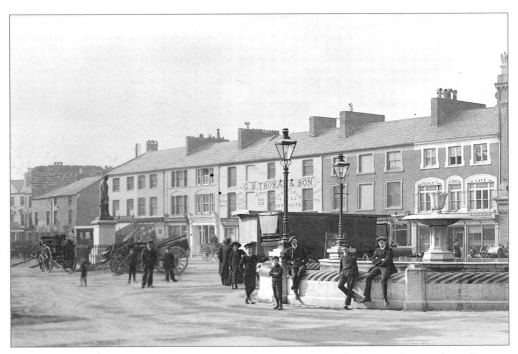

The life of Caernarfon revolves around Castle Square and most of the postcard views show this part of the town. In early views there is usually a fountain central in the square, (now gone). A cholera epidemic hit the area in 1866, the cause being an inadequate town water supply. This fountain, unveiled by HRH the Prince of Wales in 1868, was part of an attempt to remedy this. Modern-day views usually show the square being used as a bus venue. The large roundabout in the photograph below has now gone.

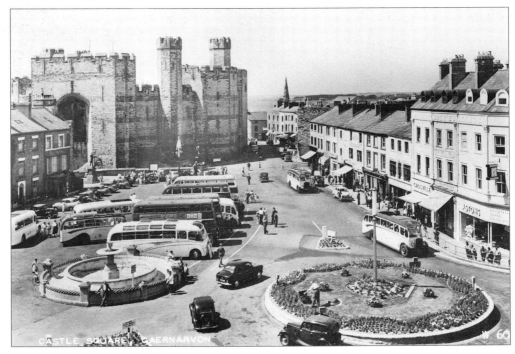

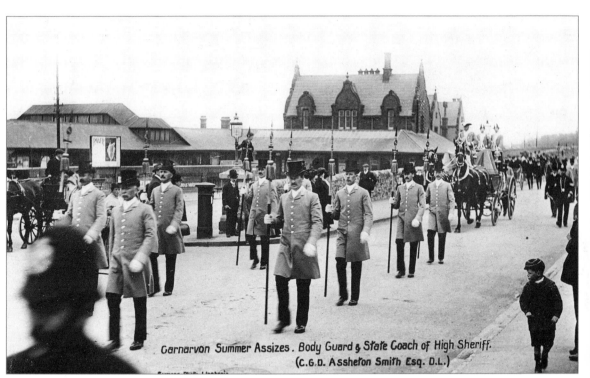

Carnarvon Summer Assizes. Body Guard & State Coach of High Sheriff.
(C.G.D. Assheton Smith Esq. D.L.)

Caernarfon is a centre for jurisprudence in Gwynedd, holding regular assizes. The photographs on this page show the extent of the pomp and ceremony associated with the opening of the assizes.

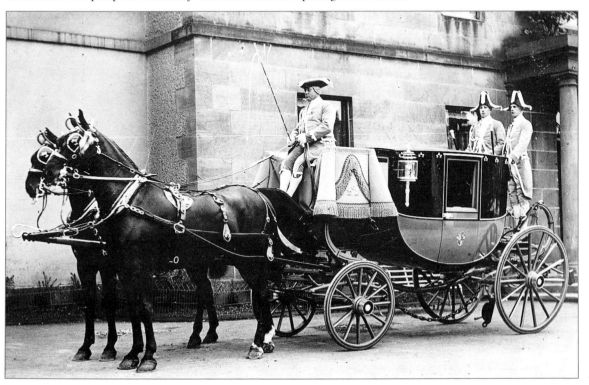

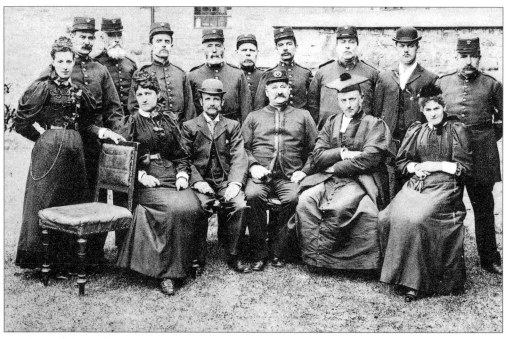

The formidable staff of the town gaol in 1892. The thought of incarceration in Caernarfon Gaol, along with Beaumaris Gaol on Anglesey, was a considerable deterrent to any would-be wrongdoer.

William Murphy (seated), a man of Irish extraction, was the last man to be executed in Caernarfon Gaol in 1910. He was an itinerant railway worker who met a married woman, Gwen Ellen Jones of Bethesda, and they subsequently had a child. In a fit of jealous rage he murdered her on Christmas Night 1909 in Holyhead, Anglesey. He then gave himself up to the police and guided them to her body. He pleaded his innocence at Beaumaris Assizes but was found guilty on 26 January 1910. Henry Pierrpoint was the executioner.

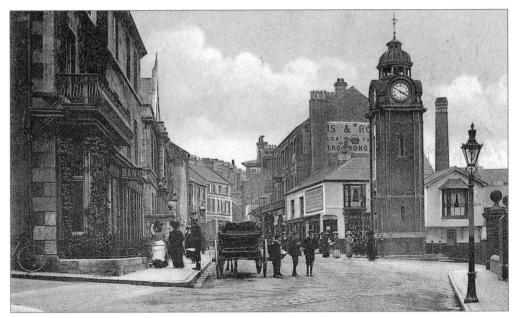

Bangor is first and foremost a cathedral and university city. In 1797 Bingley wrote of the town that, 'a spirit of improvement would render it one of the most beautiful places in Great Britain'. It is not a city of dreaming spires, though the university building is the most imposing structure in the city. It is situated in a narrow valley, and its High Street is cramped and crowded with a pleasant bustling atmosphere. During the academic year the town is dominated by the presence of thousands of students. Industrial development occurred around the Hirael and Garth areas of the town, such as shipbuilding, slate quays, writing slate manufacture, a foundry and a saw mill. Telford's suspension bridge was a spur to growth, and the town became a centre for tourism. Railway development added to the town's attractions. The establishment of the Normal College in 1858 for the training of teachers and the opening of the University College in 1884 made it the centre of higher education in North Wales.

The photograph below shows the George Hotel, which became the Men's Hostel of Bangor Normal College, and is now the University College of Wales, Bangor.

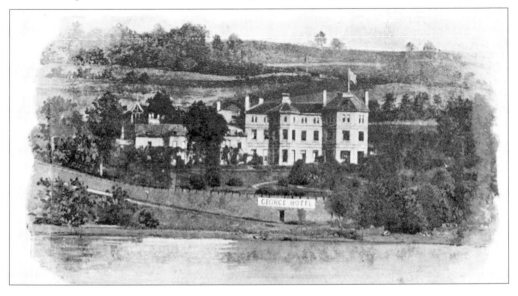

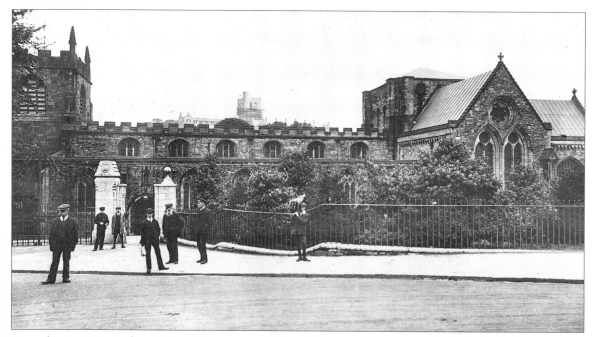

Bangor's city status is derived from the presence of the rather unprepossessing cathedral, which for over 1,400 years has been the mother church of a diocese that stretches over a quarter of Wales. The Cathedral of St Deiniolen is the oldest bishopric in Great Britain, and it has a chequered history. It was consumed by fire and destroyed and rebuilt many times. Bishop Anian, with Edward I's encouragement, was responsible for a great deal of its enlargement and refurbishment, and his illuminated pontifical is one of Wales's most precious books. Giraldus Cambrensis and Archbishop Baldwin of Canterbury preached here, seeking support for the third crusade. It was founded in 546 by St Deiniol fifty-two years before the founding of Canterbury Cathedral by St Augustine. The cathedral is the burial place for three Welsh princes and eleven bishops.

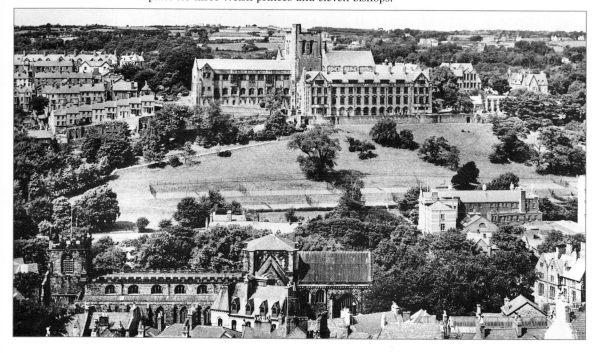

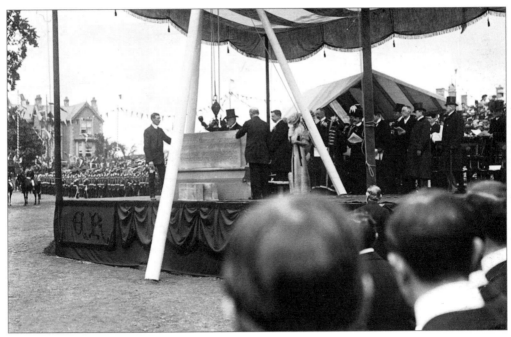

'The College on the Hill' dominates the town views. The University College received its royal charter in 1885, one year after it had opened on 18 October 1884. It began with an academic staff of 11 and a student body of 58; its first home was a redundant coaching inn. By 1900 the student body had swollen to some 300 with a dozen professorships and allied staff, and a women's hall of residence had been built by this time. Building began on the present site in 1907 and the photograph above shows Edward VII laying the foundation stone. Construction is in progress in the photograph below. HM King George V opened the first part of the building in 1911. A massive expansion programme has followed: in 1946 there were 502 students; in 1962, 1,600; and today there are in excess of 7,500 students.

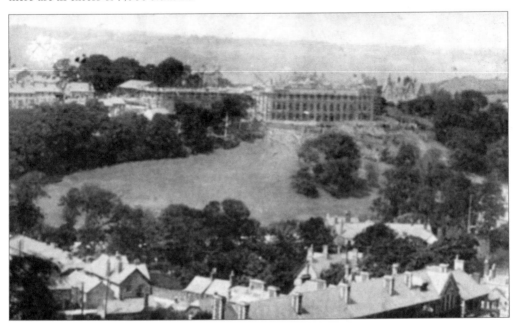

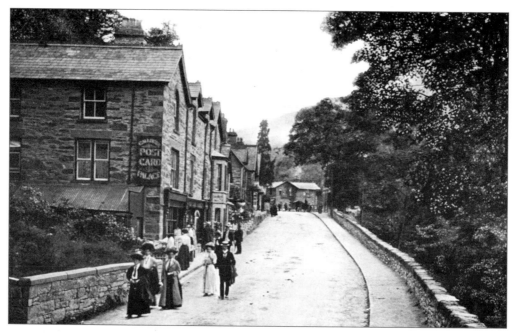

Betws y Coed. Within and around this beautifully situated tourist centre there are so many attractions for visitors that they can only be listed here: among them are the Swallow Falls, Pont y Pair, Waterloo Bridge, the Church of St Michael, Fir Island, Miner's Bridge and Fairy Glen.

The name Betws y Coed means the 'Chapel [prayer house, sanctuary] in the Wood'. 'Betws' is a 'bead house' for saying the rosary.

During the season it is besieged by visitors and to some extent suffers from its reputation as a tourist centre. It sits astride Telford's road (the A5) and provides easy access to many lovely parts of Snowdonia. During its history it has gained a reputation as a honeymoon resort, but is also a great favourite with anglers and artists.

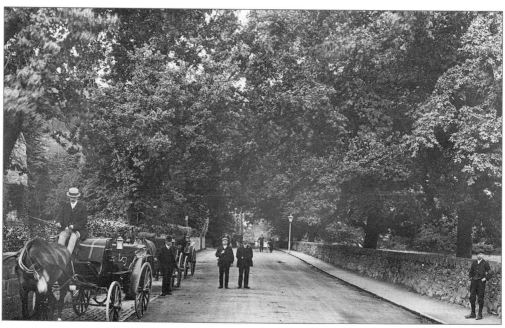

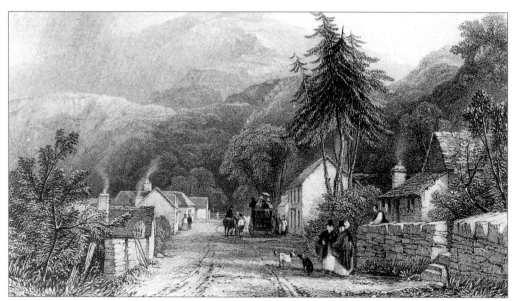

Betws y Coed, 1836, engraved by Thomas Creswick. Betws y Coed was renowned as a centre of profuse artistic activity. The Victorians' voracious appetite for the picturesque drew artists, both amateur and professional, into this part of Snowdonia by the hundreds, as its beauty presented them with inspiration wherever they turned their eyes. It was also very accessible because it lay astride Telford's road. Among the many artists who visited was the great J.M.W. Turner who came to the area on two of his Welsh sojourns, in 1798 and 1802. The renowned David Cox, a prolific and gifted landscape painter, visited so frequently between 1844 and 1856 that many people consider him to be a Welsh artist, though he was born in Birmingham. He invariably stayed at the Royal Oak, which at that time was a small whitewashed hostelry run by one Edward Roberts. Cox, it is said, was strapped for cash on one visit and paid for his board with an oil on wood painting showing Charles II hiding in the oak at Boscobel. The old signboard was passed on to the new Royal Oak, which was built in 1861. The valuable painting is now kept under glass and hangs above the fireplace in the hotel.

The Miner's Bridge with amateur painters, *c.* 1900.

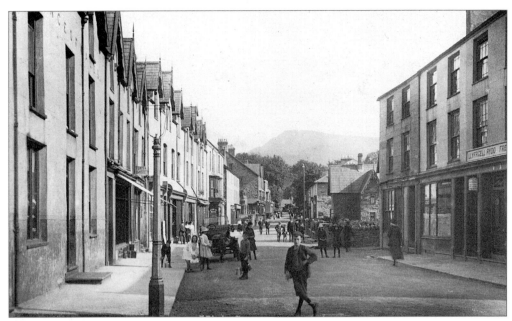

At the entrance to the dramatic Llanberis Pass lies the town of Llanberis itself, dominated by the slate quarries which gave rise to its growth. It was originally a copper mining village. In 1781 Pennant described it as, 'two groups of wretched houses and a church'. Llanberis is the closest town to Snowdon, and the mountain railway starts here. In the early history of tourism in the area the relative inaccessibility of the town hampered its development as a tourist centre. This was put right in 1832 when the pass was opened, and at the same time there was improved access to Caernarfon. In 1869 the 8-mile rail line link with Caernarfon was opened. The line was jointly owned by the LNWR and the Caernarfon and Llanberis Railway Company. The LNWR had stepped in when the Caernarfon and Llanberis company experienced financial difficulties. This line was crucial to the growth of tourism in the town, and was instrumental in giving Llanberis an unassailable advantage in attracting visitors. The line closed in 1964 during the short-sighted closure policy of the Beeching era. The photograph below shows the Llanberis main-line station at the beginning of the twentieth century.

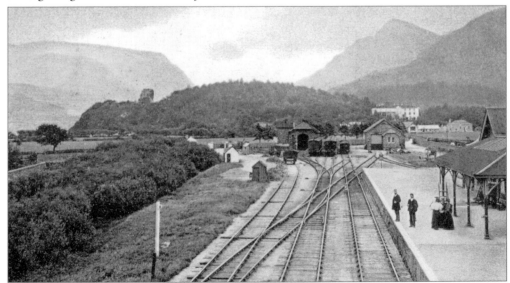

For the past 200 years much of the wealth of Beddgelert has depended on the nearness of Snowdon and the story of a faithful hound. Initially the village was the seat of a medieval priory founded by St Celert, after whom the village is named. At the end of the eighteenth century it became a centre for the Cornish tin miners who came to the area searching for copper. Together with Caernarfon it was the source of mountain guides who were obligatory companions on any ascent of the mountain. The building of the Llanberis Pass in 1832, and the mountain railway at Llanberis later, had a drastic effect on the economy of the village because it switched the centre of tourist activity to the other side of Snowdon. Although difficult to conceive, the village once had a sea connection; in truth it was a thriving port until Maddocks built his embankment at Porthmadog. The sea is now some 5 miles distant from the village. The story of Gelert, the faithful hound, is common to other villages in Europe, and is to be taken with a pinch of salt. The grave (below) is still a big tourist attraction. Merlin, King Arthur and Vortigern are associated with the area. Beddgelert is the starting point for three well-troden tracks to Snowdon's summit: Rhyd Ddu Path, Snowdon Ranger Path and the Watkin Path. The beautiful mount Hebog is on the outskirts of the village.

When the national park was designated in 1951, Blaenau Ffestiniog, a town almost at its centre, was excluded along with other slate-producing areas. As an industrial town with huge slate tips towering over it – grey terraced houses blending to give a gloomy view, particularly in the rain – it was considered to be a blot on the landscape. Now, some fifty years later, the quarries yield very little slate, and the once ugly town is a centre of tourism for those interested in industrial archaeology, narrow-gauge railways and sites which are monuments to the dignity of labour. At the end of the nineteenth century the town was one of the most densely populated areas in Wales; a thriving community with crowded nonconformist chapels. From 1801 to 1881 the population of Blaenau Ffestiniog rose from 732 to 11,274 and from 1901 to 1951 the population declined from 11,435 to 6,920. Most of the chapels are now empty shells, or converted to more earthly uses.

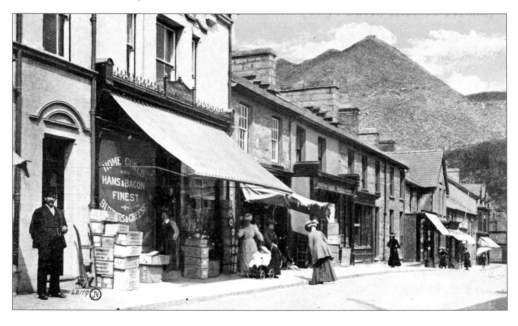

The village of Trawsfynydd is on the A470 between Blaenau Ffestiniog and Dolgellau, on the shores of the beautiful Llyn Trawsfynydd, a Liverpool Corporation Reservoir. The lake is 3 miles long and 1 mile wide. Two miles from the village is Tomen y Mor, an important historical site; it was a Roman fort and occupied from AD 78 to AD 140. There is evidence of a small amphitheatre adjacent to the site. A tankard found here, and held in Liverpool Museum, is a fine example of Celtic craftsmanship. The Normans arrived later and there are signs that they built a small motte and bailey castle, an assembly point for William Rufus and his army in 1095.

Trawsfynydd village square, *c.* 1910.

In the main street of Trawsfynydd is a statue of Ellis Humphrey Evans (Hedd Wyn), 'the Shepherd Poet'. He was born in 1887 at the farm of Yr Ysgwyn, situated just outside the village. He won many chairs at local eisteddfodau for his poetic prowess before joining the Royal Welsh Fusiliers at the outbreak of the First World War. He entered a poem in the 1917 National Eisteddfod at Birkenhead, but before the results could be announced he was killed in action. There were mixed emotions when it was known that he had won the prestigious Bardic Chair and it was presented draped in black. The occasion is remembered as Y Gadai Ddu (the Black Chair) Eisteddfod. The photograph above shows Hedd Wyn's home and the chairs won by him.

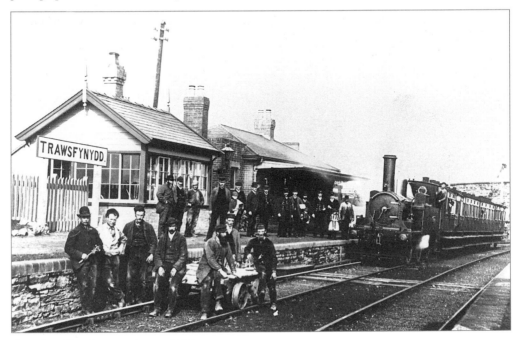

Trawsfynydd railway station, *c.* 1900.

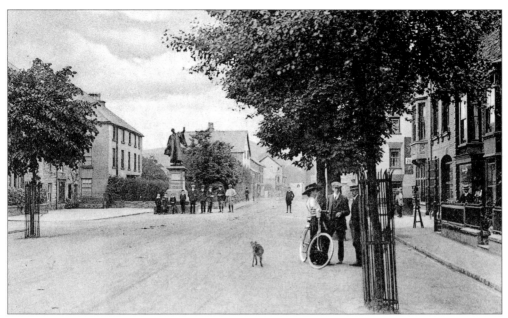

At the northern end of the largest natural lake in Wales, Lake Bala (Llyn Tegid), lies the town of Bala. The area has everything: lovely scenery, fish, folk tales, yachting, narrow-gauge railway, and is pleasantly suited to tourism. The lake, through which flows the Welsh Dee, is a joy. The town is steeped in Welsh nonconformist history, and Arthurian legend. A mound behind the old grammar school, Tomen y Bala, is believed to be the site of Bala Castle, which was captured by Llywelyn the Great in 1202. The Revd Michael Jones (b. Llanuwchllyn) started a movement in the area that led to the establishment of an independent Welsh state in Argentina, Welsh Patagonia. In May 1865 the *Mimosa* set sail from Liverpool with 153 emigrants aboard, off to establish 'Y Wladfa' (the Colony). Over the years some 3,000 people migrated to 'Y Wladfa', and nowadays there are 35,000 descendants, mainly Spanish speaking; however, several hundred still speak Welsh and maintain a Welsh cultural heritage.

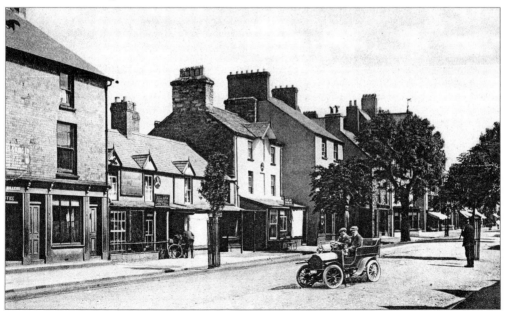

Statue of Thomas Charles, one of Bala's world-famous figures. In 1783 Thomas Charles married a Bala girl and settled in the town. He was a curate of the established church but became attracted to nonconformism and became a member of the Calvanistic Methodist movement. He was instrumental in the founding of the British and Foreign Bible Society and was a founder of the Sunday School movement, centres for the secular as well as religious education of those who asked for it. Mary Jones of Llanfihangel y Pennant is said to have walked barefoot for 25 miles over the mountain to Bala to purchase a bible from Thomas Charles, and this prompted him to set up the British Foreign Bible Society. His memorial statue is situated in front of Tegid Chapel and he is buried at Llanycil Church beside the lake.

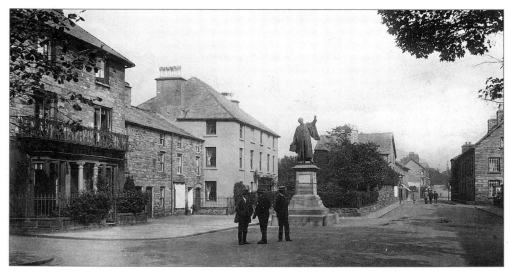

A statue in Bala's main street commemorates the life of Thomas Edward Ellis who was born in 1859 at Cynlas Farm, 3 miles from the town. He was a prominent figure in British politics in the late nineteenth century, and was also an unrelenting worker in the fields of education and religion. He was the Liberal chief whip from 1894 until his death in 1899. More famous Welshmen associated with the town's grammar school are Daniel Owen, Sir Owen M. Edwards and Dr John Puleston Jones (the blind preacher).

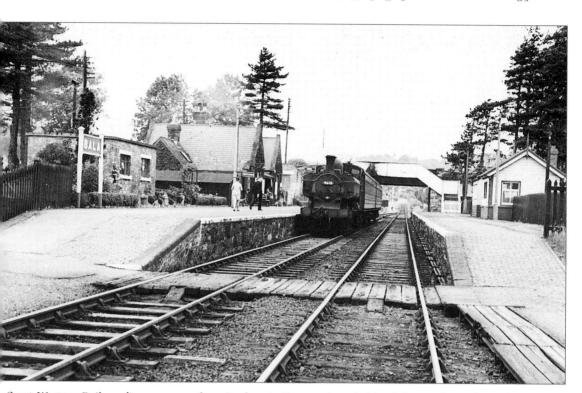

The Great Western Railway line once ran from Ruabon to Barmouth and skirted the southern shore of Lake Bala. This valuable tourist asset was stripped away by the infamous Beeching programme in 1965. In 1971 Rheilfford Llyn Tegid Cyf (Bala Lake Railway Ltd) was formed, and set up a narrow-gauge line between the existing standard-gauge tracks. It was the first railway preservation society to be set up in the Welsh language. The 1 ft 11½ in line runs between Llanuwchlyn and Bala, and is a great tourist attraction.

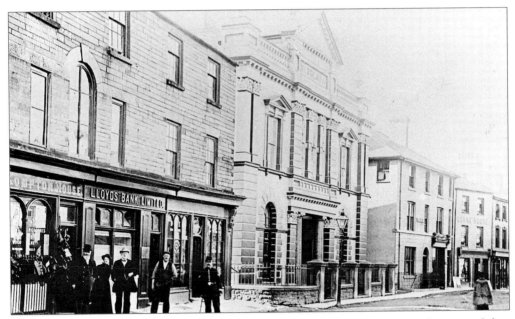

Bethesda is a town of relatively recent origin which owes its presence to the development of slate quarrying. At one time the town housed more than 2,000 workers from the Penrhyn Slate Quarry, which still operates, though at a greatly reduced rate. It is said that slate was quarried here during the reign of Elizabeth I but systematic quarrying did not take place until the eighteenth century, when Richard Pennant of Liverpool married the Penrhyn heiress; he subsequently became Baron Penrhyn in 1783. The area was originally called Glanogwen, but to cater for the souls of his workers several large chapels were built and given Biblical names; Bethesda was one such, shown above, and the town was named after it. Mary Elizabeth Thompson came to live in the town in 1937 and using the town as a base she visited all of the North Wales quarries and pits. Her beautifully executed drawings are held in the National Museum in Cardiff, a lasting record of a life that is fast disappearing.

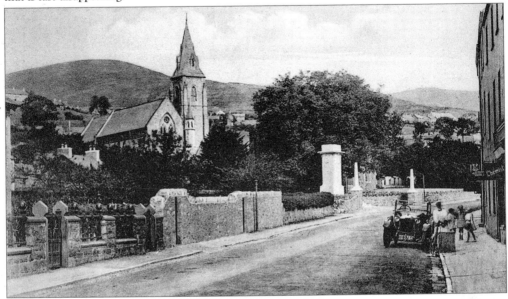

The War Memorial and Glanogwen Church, Bethesda.

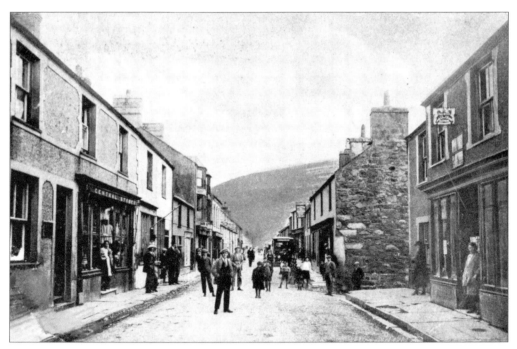

During a period in the middle of the nineteenth century there was rapid growth in the slate industry. The population of Caernarfonshire, for example, increased by some 22 per cent, and the slate workers began to create their own little village communities. The nonconformist parishes clustered around their chapels and usually called the village by the name of the first chapel built, as at Bethesda. There are two more examples on this page: Ebenezer (above) grew up in Llandeiniolen parish, and Bethel (below) developed near Caernarfon.

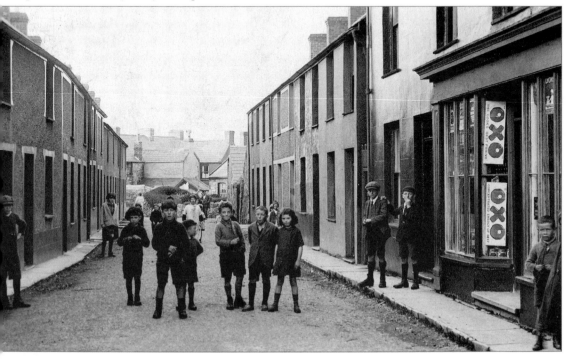

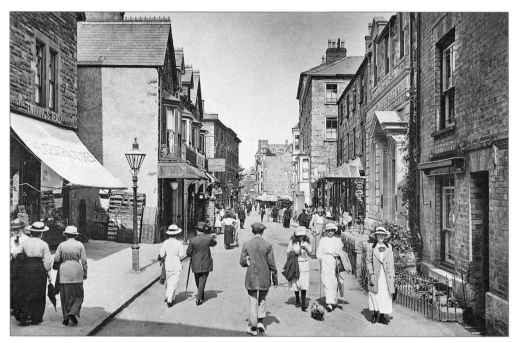

Barmouth lies at the mouth of the lovely Mawddach Estuary, an old river valley carved by an ice age glacier. The beauty of this area so impressed John Ruskin that he said the journey from Barmouth to Dolgellau could only be compared with the journey from Dolgellau to Barmouth. The town, which is really a product of the nineteenth century, was once a thriving ship-building centre with over 200 coastal traders constructed in its yards. Charles Darwin was very fond of the town and spent several weeks there while writing *The Descent of Man*. Above the town lie the cliffs of Dinas Oleu, the very first piece of land purchased by the National Trust in 1895. On the other side of the estuary runs the Fairbourne Miniature Railway.

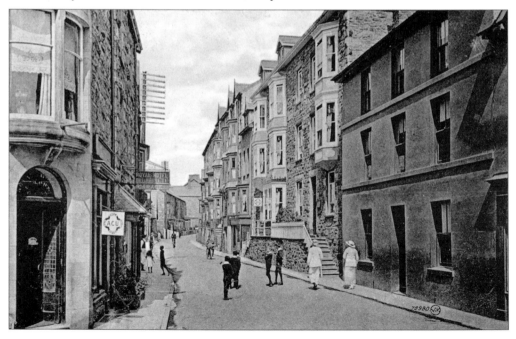

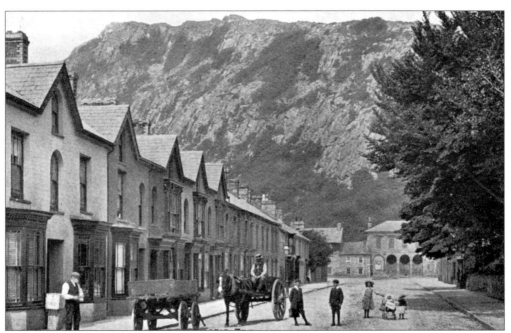

Tremadog High Street, *c.* 1908 (above) and Porthmadog, *c.* 1910 (below). Where Porthmadog and Tremadog are sited there once was a wide estuary of marsh and mud flats known as Treath Mawr. William Alexander Madocks (1773–1828) constructed embankments, and the town developed on the reclaimed land. Tremadog was the first to be built, and is an outstanding example of early nineteenth-century town planning. It was widely believed that this area would be chosen for the packet trade to Ireland, but Holyhead was settled on instead. Madocks sealed off the whole of the Glaslyn Estuary. Work began on both shores in 1808, and the gap was finally closed in 1811. Considering that all the stones were horse-drawn and manhandled into place it was a prodigious engineering feat. The burgeoning slate trade led to the rapid development of Porthmadog. In 1821 the population was 885; by 1861 it was 3,059. Shipbuilding became a thriving industry and developed from a small trade that had been going on at nearby Borth y Gest. In the peak year of 1873, 116,000 tons of slate left the port for destinations all over the world. By 1945 the last of the Porthmadog fleet had disappeared.

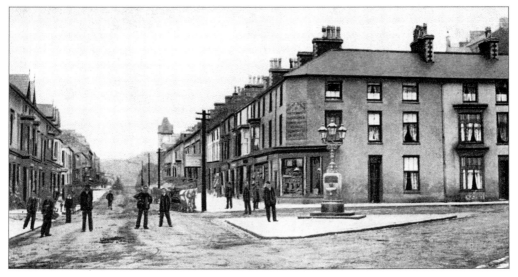

Dolgellau is a town of strong grey stone buildings sited where once three Roman roads converged on what was then a military outpost. It is the principal county town of Merioneth and much of its early prosperity was related to the wool trade, but a significant part of its development was due to the Victorian tourist trade, and the proximity of Cadair Idris. In 1404 Owain Glyndwr assembled a last Welsh parliament here and later signed an alliance with Charles VI of France to provide troops to fight against Henry IV of England. In the late nineteenth century the area became the focus for several gold rushes, and, by 1900, there were two dozen mines with a total of 500 workers in the area. In the seventeenth century Quakers came to Dolgellau seeking freedom from prosecution and built up a small community.

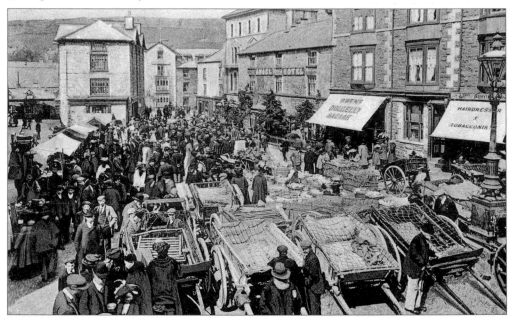

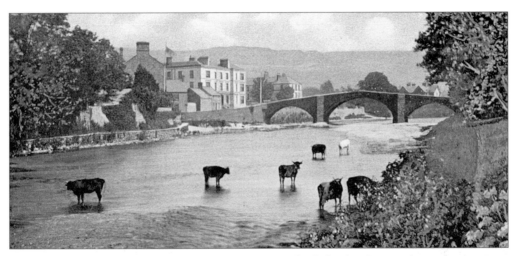

Llanrwst is the market town of the Conwy Valley and the hub of a thriving farming community which farms the surrounding lush pastures. It has a delightful setting on the east bank of the Afon Conwy. St Crwst was the Celtic saint who gave the town its name. It is a historic town with its famous bridge, which is said to have been designed by Inigo Jones, built in 1636. Pont Fawr ('large' or 'important' bridge) was for many years the main bridge over the Conwy. The old industries of the area, for example harp making and clock making, have died, but there is plenty to explore. The market hall, which is shown in the photograph below, was demolished in the 1960s and many regard this as an act of bureaucratic vandalism. A similar delinquent act was perpetrated recently when one of the town's historic hotels was allowed to become derelict and was razed to the ground almost overnight.

The stone coffin of Llywelyn the Great, 'Prince of Aberffraw and Lord of Snowdon', rests in the Gwydir Chapel of the parish church, the last memorial of 'that eagle of men who loved not to lie nor sleep, but so long as the Welsh tongue is spoke he lives again in the affection and the memory of his people'.

Rhyd Ddu in translation is the dark or gloomy or black ford. The village stands at the foot of Snowdon and the starting point for the Rhyd Ddu track to the summit. It was a station on the Welsh Highland Railwa narrow-gauge track. This line was an attempt to compete with Llanberis in the battle to attract tourism, but was never successful. T.H. Parry-Williams was born here in 1889. He was a jewel in the crown of Wels literature and was always eager to acknowledge the inspiration that his birthplace had been to him througho his life; he died in 1975.

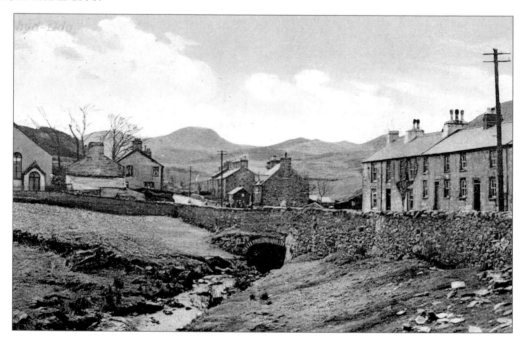

CLIMBING
IN SNOWDONIA

The Abraham brothers photograph some high spirits on Tryfan's summit at the turn of the nineteenth century.

Climbers have a high regard for the craggy rocks of Eryri. There are thousands of recognised climbing routes in the national park, and new ones are added annually.

There are no records of who first climbed the mountains of Snowdon. It is likely that the first people to reach Snowdon's summit were hunters in search of dinner, or shepherds in search of sheep. Snowdon was climbed by many of the early visitors simply because it was the highest, and there. We are fairly certain that the first person to record almost reaching the top of Carnedd Llewelyn was Thomas Johnson, the botanist, in 1639. He failed to achieve the summit because his guide was fearful of the eagles! The first recorded ascent of Snowdon was Thomas Johnson again, in 1639. He collected and listed a total of twenty plants gathered on his journey. And is it true that Halley (of comet fame) did some stargazing from the summit in 1697? In the 1780s the most famous visitor was Thomas Pennant who walked at night so he could witness dawn from the summit. In 1798 a plant-gathering expedition by two reverend gentlemen, Bingley and Williams, turned into a hair-raising climb on the dreadful cliffs of Clogwyn Ddu'r Arddu. This was the first recorded rock climb in Snowdonia, and one in which an artificial climbing-aid (trouser belt) was used to haul Bingley up a difficult pitch.

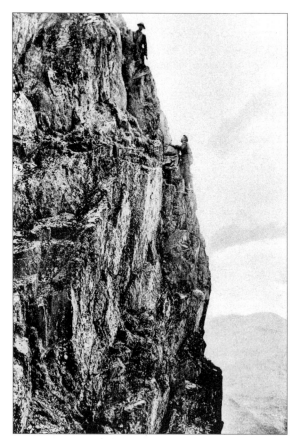

Lliwedd. Rock climbing in North Wales followed the development of the sport in the Lake District. When it began it tended to centre on Lliwedd to the east of Snowdon's summit. The cliff face towers for 1,000 ft above Llyn Llydaw. The first climbing guidebook ever written was about this cliff, and it was penned by the doyen of North Wales climbers, J.M. Archer Thomas and his companion A.W. Andrews. *The Climbs on Lliwedd* was published in 1909, and the authors claimed 'as a school for mountaineers Lliwedd is unrivalled'.

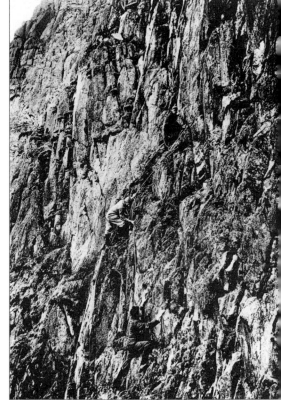

The first recorded climb on Lliwedd was by T.W. Wall and A.H. Stocker in January 1883. In their book *Mountaineering in Britain* Clark and Pyatt say it was 'the first major rock climb in Wales and one which was at least a decade in advance of its time'. The first recorded rock climbing death in Wales occurred on Lliwedd in 1888. A climb by Corlett, Evans and Kidson in the Central Gully ended tragically when 24-year-old Evans fell 600 ft to his death. By 1914 there were some thirty distinct routes on the face, and today there are many more.

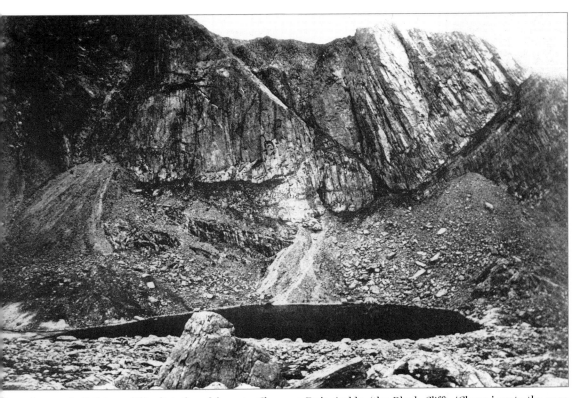

he epitome of all things difficult is found here in Clogwyn Du'r Arddu (the Black Cliff). 'Cloggy' sorts the men om the boys with a vengeance, and all the great names in the history of British rock climbing have come here nd returned again and again. There is no disputing that Cloggy has one of the largest concentrations of severe ock climbs in Britain. The first recorded climb here has already been mentioned when Bingley and Williams, in neir pursuit of plants, ascended the Eastern Terrace. Serious rock climbing began here at the turn of the ineteenth century when, for example, George Dixon Abraham and Ashley Perry Abraham (the great mountain hotographers) climbed the East Wall in 1905. From then on many first ascents were recorded by such men as erbert Carr, Archer Thomson, Longland, Piggot and A.D.M. Cox. In the 1930s the climbs were dominated by uch as Menlove Edwards, Colin Kirkus and G.G. MacPhee. Kirkus and MacPhee claimed the Great Slab on Cloggy 1930. Later, in the 1950s and '60s, Joe Brown, Peter Crew, Nat Allen, Slim Sorrell and Don Willans opened up logwyns's cliffs and redefined the boundaries of rock climbing in the area.

A climbing party at Pen y Gwryd, Easter 1897 (above). This is an Abraham brothers' photograph and in the group are, back row, left to right: C. Fox, -?-, Rudolf Cyriax, -?-, Miss Buss, C. Legros; middle row: Dr Collier, Oscar Eckenstein, Mrs Bryant, -?-, Revd Septimus Buss, A.D. Godley; front row: Miss S. Nicholls, -?-. It is interesting that there are excellent lady climbers here when popular opinion would tell us that rock climbing was probably an aggressive, competitive and exclusive male sport. Women climbers feature frequently in the photographs taken by the brothers and, at the famous Peny y Pass Easter parties, women were accorded equal status on the rocks. Miss Bryant and Miss Nicholls became the first females to climb the Central Gully with Miss Nicholls leading for over half of the climb. They founded 'The Pinnacle Club' in 1922, its aim being 'to foster the independent development of rock climbing for women'.

 Below, on Cader Idris are, from left to right: Ashley Abraham, C. Fox, W.I. Williamson, O.G. Jones and George Abraham.

A climbing party at the Pen y Pass Hotel in 1907. This is a photograph of many famous names in the history of climbing in North Wales. Back row, left to right: O.K. Williamson, -?-, Marcus Heywood, G. Winthrop Young, J. Percy Farrar, J.M. Archer Thomson; middle row: W.R. Reade, Geoffrey Bartrum, George Mallory (of Everest fame); front row: E.B. Harris, F. Don, F. Sparrow, Oscar Eckenstein.

It must be said that in those days there was a certain amount of elitism in the climbing fraternity. If one reads between the lines it is clear, for example, that the Abraham brothers of Keswick were regarded with a measure of disdain by some because they were making a living from climbing through their books and photographs. They had committed the cardinal sin of introducing 'trade' into what was regarded as the exclusive pursuit of those of liberal education and lofty aspiration.

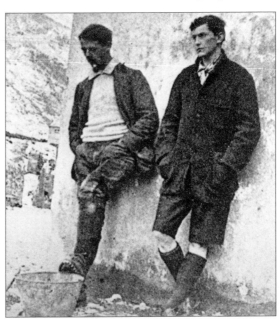

S. Herford (left) and George Mallory at the Pen y Pass Hotel in the 1920s. They had just completed a double girdle of Lliwedd with Geoffrey Winthrop Young.

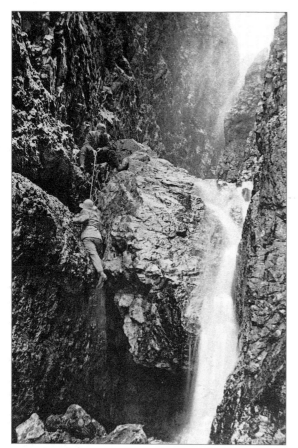

In the early years of climbing there was a great deal of rivalry with regard to first ascents and the discovery of new routes. Nowhere was this rivalry more clearly shown than in the desire to be first up the Devil's Kitchen.

O.G. Jones arrived in Snowdonia in 1895 determined to be the first. His partner Haskett Smith dropped out of the venture and though Jones attempted a solo ascent he met with disappointment. He did not know that the climb had been achieved some three months earlier by Archer Thomson and Hughes with the aid of a hatchet 'purloined' from Mrs Jones's coal cellar at Ogwen Cottage. This was an ice-assisted climb so was not officially recognised.

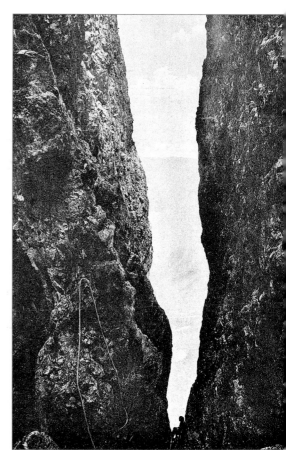

On 7 May 1898 at 6.15 p.m. W.R. Reade and W.P. McCulloch began their ascent and they completed it at approximately 7.19 p.m. This was a hair-raising climb by two Lancashire climbers more used to Lake District conditions.

Facing the Devil's Kitchen and to the left on the shores of Llyn Idwal there is a dramatic rock feature, which throughout history has been the scene of the first climbs of budding rock climbers: these are the Idwal Slabs.

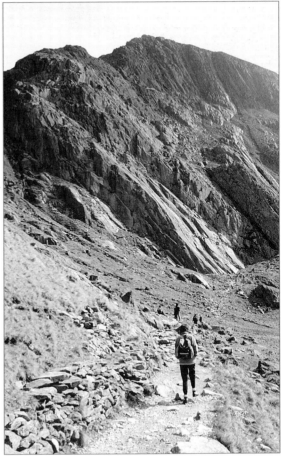

On the slabs, the rock faces are laced with a host of easy- to middle-difficulty climbs. It was here in 1952 that the author, after an attack of vertigo coupled with cowardice, decided that his future visits to Snowdonia would be spent mountain walking rather than rock climbing.

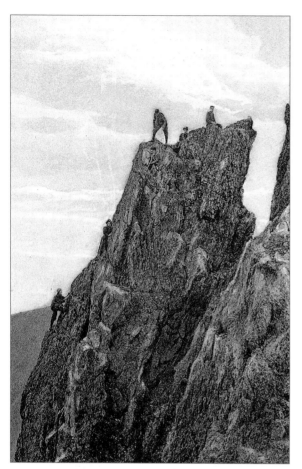

On the Horseshoe, past the narrow Crib Goch ridge, are the Crib Goch Pinnacles, a series of jagged and splintered crags much loved by the climbing fraternity. The one with the most appeal is the Crazy Pinnacle (left), named after either the character of the people who first climbed it, or the friable nature of the rock. Many famous rock climbers felt their first love for the sport on this needle, 15 ft high from where it joins the main route. Two amusing entries in the Pen y Gwryd visitor's book refer to the Crazy Pinnacle: 'So and so ascended the Pinnacle in 5½ minutes and found the rocks very easy', and 'The above party descended the Pinnacle in 5½ seconds and found the rocks very hard.'

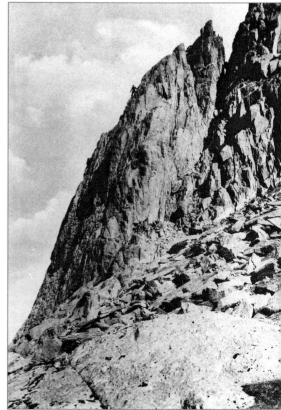

One of the strangest visitors to Snowdonia was the Climbing Parson, who climbed the skylines and ridges for many years in and around 1840. No one knows who he was, and so he remains a man of mystery. Tall and angular in clerical garb, with an 8-ft alpenstock, he climbed only the skylines. He pioneered the route over the northern spur of Crib y Ddysgil, and his legacy is a name for the route, the Parson's Nose (Clogwyn y Person). A writer of the time, describing him on his ridge walks, said: 'He took no food but put a pebble in his mouth when he wanted drink. He was generally reckoned to be on his legs from 9 a.m. to 8 p.m. and spent several weeks annually in North Wales.' This photograph of the Parson's Nose is by the Abraham brothers, and if the parson climbed this route alone, it was indeed a prodigious climbing feat for the time.

Adam and Eve on Tryfan. When Bingley
saw these two rocks from the roadway early
in the nineteenth century he mistook them
for two people standing on the summit
chatting and admiring the view over Llyn
Ogwen. This is still a common
misconception and, needless to say, they
have been admiring the view for many
thousands of years. The photograph above
shows Wyn Jones becoming a free man of
Tryfan, for the umpteenth time, by stepping
across the gap between Adam and Eve.

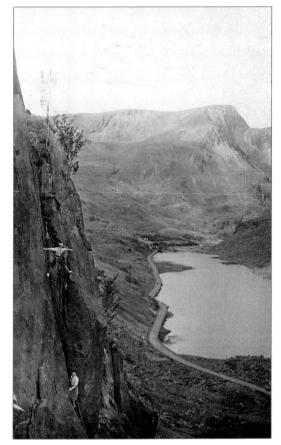

The Milestone Buttress (right) is a very
popular climb on Tryfan. The climb is so
named because it coincides with the tenth
milestone from Bangor on the Capel Curig
road. The proximity of the road, and
parking facilities, makes this crag an ideal
place for spectators from the A5. The climb
was pioneered by O.G. Jones and was
popularised by a report of an ascent by the
Abrahams in 1904. Their colourful account
is enlivened by an encounter with a
decomposing dead sheep at a critical point,
part-way up.

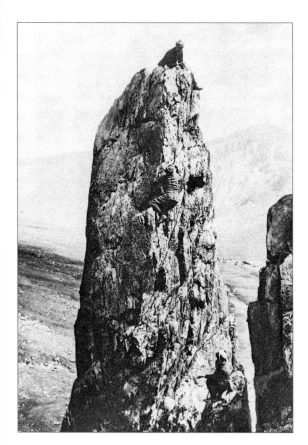

In *Rock Climbing in North Wales* the Abrahams point out that the Carneddau 'present a singularly uninteresting appearance', seeming to be 'nothing more than huge grassy mounds'.

On a climb on Scawfell Pike in the Lake District the Abrahams saw something of great interest. Over 100 miles away they saw the snowy peaks of Wales, and with strong binoculars the two Carneddau became strikingly clear, particularly the craggy and rugged nature of their northern cliffs above Cwm Llafar, the north face of Carnedd Llewelyn, and Craig y Ysfa. Thus began a long affair with these rocks, and their book contains interesting accounts of the days they spent there, as well as some spectacular photographs, two of which are reproduced here.

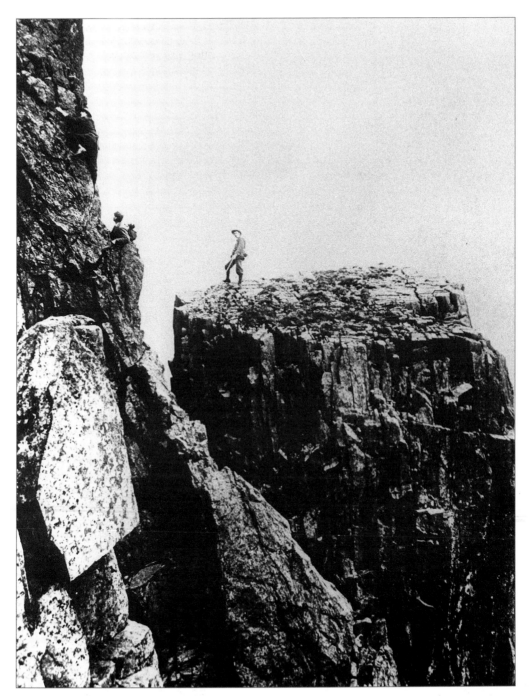

A historic climb on the Cyfrwy Arete on Cader Idris. O.G. Jones, a mountaineer's mountaineer, experienced his first rock climb here in May 1888. He was a complete novice and very badly equipped. He was twenty-one, climbed alone, and didn't even have hobnailed boots. He later introduced the Abraham brothers to the climb, and they loved it because the shelf seen here provided them with an excellent stand for their camera tripod. This early experience must have given O.G. Jones a real taste for climbing; he went on to achieve worldwide fame, and his book, *Rock Climbing in the English Lake District*, became a classic.

A distinctive feature on the north ridge of Tryfan is 'The Cannon'. The climber in the photograph is Gerry Lynch, a well-known local climbing instructor. He has devoted his life to instructing people in all aspects of mountain craft, and many thousands of schoolchildren owe him a debt of gratitude for his wise and pertinent advice.

The Snowdonia Society, who have their headquarters in the 'Ugly House', are an environmental pressure group devoted to conserving the essential nature of Snowdon. The photograph was taken recently during one of their many walks in the mountains. In the group are Derek and Jean Price, Frances Richardson and Alan Evans.

John Grisedale meets two air crew of 22 Squadron, RAF Valley, Air Sea Rescue. The photograph was taken during a training exercise for the Mountain Rescue Team in Cwm y Ffynon, high above the Llanberis Pass, in 1995.

Climbers themselves formed the earliest rescue groups, frequently aided and guided by local farmers and quarrymen; later the various climbing organisations decided that such a dangerous and supremely important duty should be properly organised with specialised equipment. Consequently they set up volunteer rescue points suitably equipped. From 1947 to 1967 the prime mover in this respect in Snowdonia was Chris Briggs BEM, DL, the proprietor of the Pen y Gwryd Hotel, a famous climber and mountain man.

More members of the Mountain Rescue Team on exercise in Cwm y Ffynon in 1995. In the group are John Grisedale, John Ellis Roberts, Neil Rawlinson and Peter Walker.

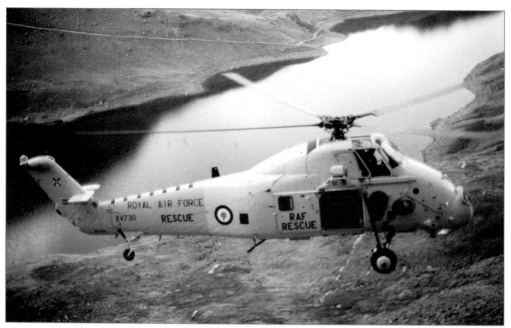

A rescue on the slopes of Lliwedd in 1995. The yellow Wessex helicopters of 'C' flight are an all too familiar sight to the residents of North Wales, both on the coast and in the mountain regions. The flight was formed at Valley airport, Anglesey in 1955, and is on 24-hour standby at Valley as part of 22 Squadron. The Wessex can carry up to fifteen survivors and has a range of 300 nautical miles with a maximum speed of 120 knots. It carries a crew of three: pilot, navigator and winchman. The winchman has the most dramatic role to play in any rescue, swinging at the end of a line, which can be 100 yd long. Winchmen are qualified to administer first aid at the scene of an incident but their primary role is to use one of the available rescue aids to enable the casualty to be taken to specialist help, usually at Ysbyty Gwynedd at Bangor. (The photographs on this page were taken by Harvey Lloyd.)

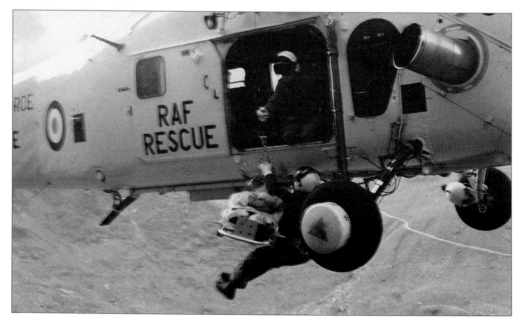

HOSTELRIES & HOSTELS

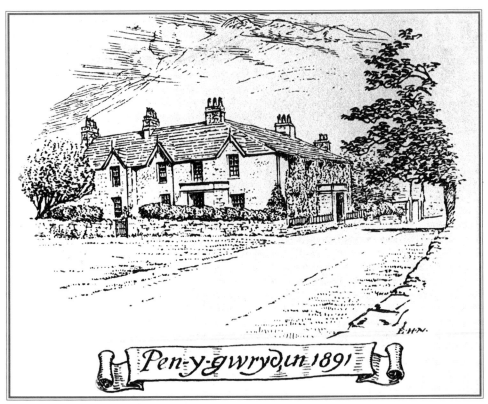

Pen-y-gwryd in 1891

In the early years of the development of Snowdonia as a tourist centre the hotels played a much more influential role than they do today. They were an integral part of the area's transport system in that they allowed for the change of coach horses as they completed a stage of their journey, and provided overnight stops for travellers wearied by long journeys on poor road surfaces. They also supplied guides for excursions into the mountains, and particularly to the summit of Snowdon. There were many hotels in Snowdonia's towns and large villages, which provided termini for the commercial and tourist trades. In the countryside there was accommodation at country hotels, usually for one night stays; these tended to be the heart of mountain tourism. There were many smaller inns, which offered a boarding house life of meals, rest and refreshment. In 1820 Caernarfon boasted eighteen licensed premises and four large hotels for a local population of 4,000 people. Rich in number and poor in quality seems to be the general rule regarding remote hotels in the early years; the accounts of the early itinerants are replete with stories of plain and inadequate feeding, and beds shared with a rich variety of insect life.

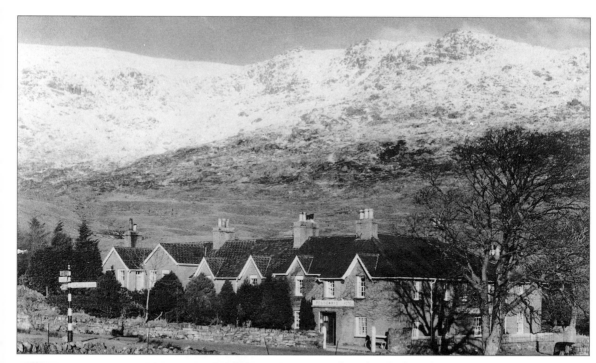

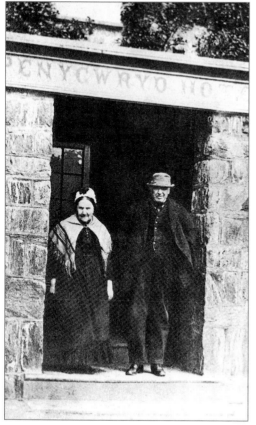

Pen y Gwryd. In the climbing fraternity this is one of the most famous hotels in the world. It is the one most associated with Snowdon and was used as a training base by the 1953 Everest expedition. The first mention of the hotel was in 1830 when Benet in his *Pedestrian Tour of North Wales* was, to say the least, less than complimentary. In 1836 Roscoe, another travel writer, described it as 'the worst hotel encountered on my journey through Wales, and the charges were, beyond measure, extravagant'. His night's sleep was bedevilled by fleas, and when he complained to the serving wench he was told: 'Dear me Sir, if we killed one, ten more would come to the funeral.' It was, he concluded, 'a dirty and wretched place'.

The Pen y Gwryd was transformed in 1847 when Henry Owen, his wife Ann and his mother-in-law took over. They stayed for forty-four years. A list of its patrons was a 'Who's Who' of the rich and famous of the time: William Gladstone, David Lloyd George and Winston Churchill all stayed there, along with great men of literature and science. The visitors' books, with the signatures and comments of the famous, became very valuable social documents, and were eventually stolen. The famous 'Climbers' Club' was formed here in 1898, after some years of being called the 'Society of Welsh Rabbits'. Among the early climbers were great names in the history of mountaineering such as Archer Thompson, O.G. Jones, Oscar Eckenstein, the Abraham brothers, Winthrop Young and George Mallory.

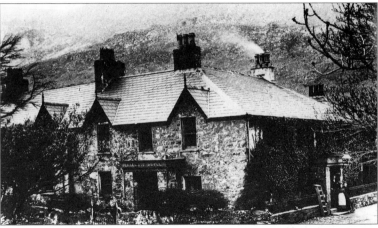

Henry Owen died in 1891 and despite valiant efforts on the part of Mrs Owen and her grandaughter Kate (left), the hotel went downhill. In 1902 the official receiver was in residence. Then the second long-stay landlord appeared. He was Arthur Lockwood, an electrical engineer who worked at the Cwm Dyli power station, he married Miss Pritchard, the landlady of Pen y Gwryd, and moved in in 1909. For thirty years he was the chief influence on the hotel. He was no mean climber, and has a climb, 'Lockwood's Chimney' above Llyn Gwynant, named after him. He created a lake outside the hotel and stocked it with fish for the hotel's patrons. During the war the buildings were used as a school and in 1945 Lockwood left. He died a very old man, in 1973. Christopher Briggs became the landlord in 1947. He was later awarded the BEM for his services to mountain rescue.

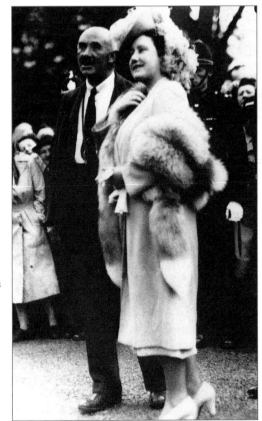

The photograph on the right has caused some discussion as to what precise event it commemorates. The consensus is that it was taken on 18 July 1946 when George VI and Queen Elizabeth visited Pen y Gwryd on a tour of prospective national parks. The Queen is talking to Arthur Lockwood. Their host on this occasion was Clough Williams-Ellis, the architect of Portmeirion, an ardent advocate of the establishment of National Parks throughout the United Kingdom. He had bought a ridge overlooking Nant Gwynant and presented it to the National Trust. It was thanks to him and pioneers of his sort that National Parks came into existence. His words from *England and the Octopus* are worth repeating: '. . . man cannot survive in full bodily and health and spiritual vigour if denied the healing contact with unmanipulated Nature that the wild places of our teeming country can still afford.'

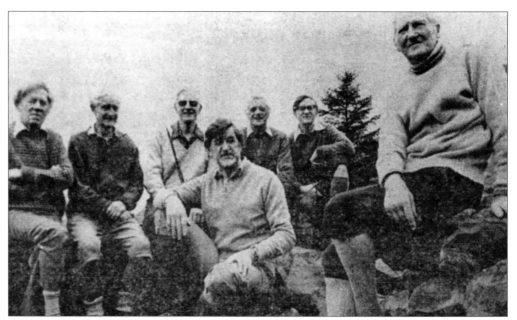

The 1953 Everest expedition outside the Pen y Gwryd Hotel for a thirty-year reunion in 1983. The men used the hotel as their base when they were preparing for their successful Himalayan summit attempt. Using Snowdonia as a training ground, they planned and tested equipment, and perfected climbing techniques. Before leaving, they each signed the ceiling in the hotel, a feature which has had to be covered with glass because of the attentions of graffiti vandals with felt-tipped pens. Apologies for the technical quality of the photograph below, which is the signed ceiling.

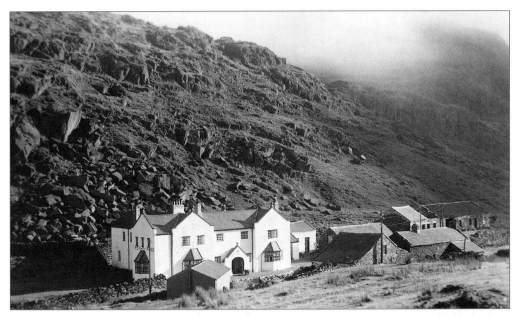

Gorphwysfa Hotel (Pen y Pass). In the deep shadow of the Llanberis Pass stands the Pen y Pass Youth Hostel, which was once the Gorphwysfa Hotel. Until 1848 two heaps of stones stood at the head of the pass and at this date a small inn was built there. It did not attract nearly as many mountain visitors as the Pen y Gwryd until 1900 when Owen Ranson Owen took over as landlord. From this date the inn blossomed and there was extensive rebuilding and enlarging of the premises. Climbers such as Geoffrey Winthrop Young were attracted to the hotel. He extolled its virtues, where the mountaineer was 'Lodged upon the rim of space' on 'the highest roosting place on the island'. The pinnacle of Crib Goch is just across the road from the hotel.

From 1900 to 1950 the hotel became the premier centre for the Snowdon massif and attracted all of the world's finest climbers. It became the headquarters of the famous Climbers' Club and was noted for its Easter parties organised by the incomparable Geoffrey Winthrop Young (pictured). Vaynol Estates sold the hotel in 1967 to the Youth Hostel Association and, after some opposition from the Snowdonia National Park Society, it became a youth hostel. Harvey Lloyd was the hostel warden for twenty-five years up to 1997.

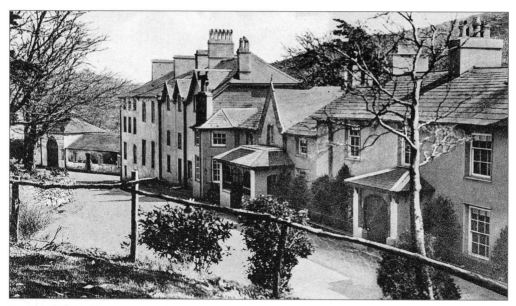

Royal Hotel, Capel Curig. Lord Penrhyn built this hotel as a continuation of his road building project in 1804. It was known initially as the Capel Curig Inn, but was changed to the Royal Hotel in 1834 after a visit from the young Princess Victoria. It was a large rambling building with over sixty bedrooms. Hyde Hall said that in his day the inn acted as a 'sort of pivot on which the intercourse between London and Dublin turned'. Stagecoaching and post housing were essential to its well-being; when the railway came to Bangor a lot of this trade was lost, and the fortunes of the inn declined. Eventually climbers moved into hotels and huts nearer the central mountain massif. In 1955 it became Plas y Brenin, a centre for outdoor activities associated with mountains and lakes.

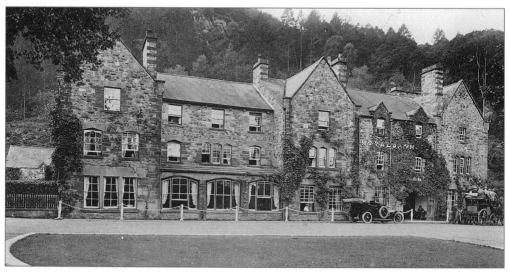

Royal Oak Hotel, Betws y Coed. This hotel is mentioned elsewhere when the artistic life of Betws y Coed is discussed (p. 77). It started life as a small whitewashed cottage run by Edward Roberts, but in 1861 was rebuilt with greatly enhanced facilities. The Royal Oak signboard painted by David Cox hung out in the elements for many a year until its value was recognised (in 1880 it was valued at £1,000). It is now preserved under glass in the hotel, and is insured for a sum considerably in excess of £1,000.

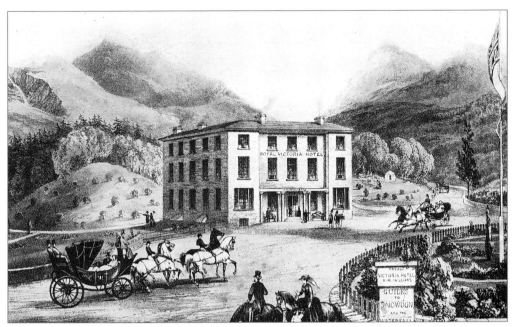

The Royal Victoria Hotel, Llanberis, became the centre for tourism in Snowdonia. It was built by Assheton Smith, the Vaynol Estates landowner. Roscoe described it as a 'handsome hotel'. The building of the hotel was prompted by a proposed visit by Princess Victoria, hence the royal appellation. The future queen did not come; instead, the Duchess of Kent arrived alone. It was opened in 1832 and the first landlord was Edward Green who stayed for thirteen years. The Prince of Wales visited in 1869. It was one of the principal centres for the provision of ponies and guides for the trip to Snowdon's summit.

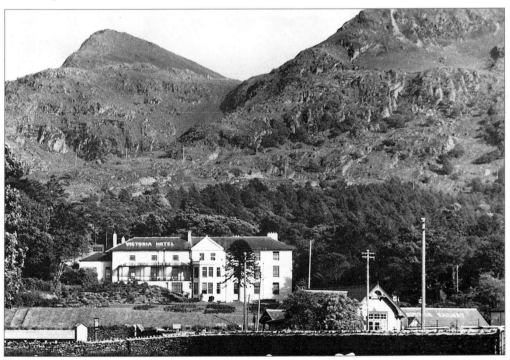

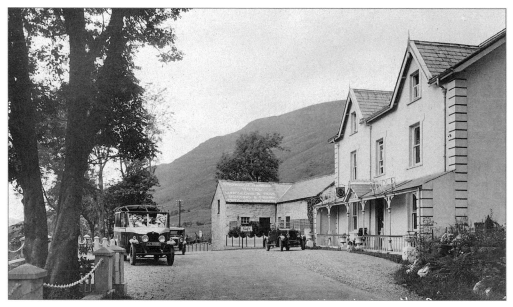

The Snowdon Ranger was one of the first recorded hotels in the district though it did not achieve any great fame. It is remembered chiefly as a starting point for Snowdon's summit and was described in *Letters from Snowdon*, 1770, by Joseph Cradock as 'a small thatched hut inhabited by a labouring man with five or six children'. Cradock stayed there overnight and was entertained by a blind harpist and a gang of buxom wenches who danced for his pleasure. In the mid-nineteenth century its landlord was John Morton who claimed, in conversation with George Borrow, to be the original 'Snowdon Ranger' and to have named his house after himself. In 1874 Murray described it as 'a solitary but comfortable little inn, much patronised by anglers, adjoining lake Cuellyn'. In the photograph below, taken in about 1910, it is playing host to a cycling club. It is now a youth hostel.

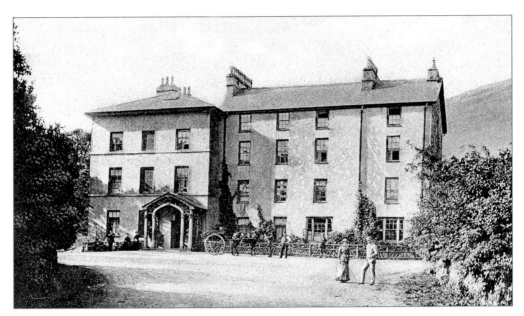

The Goat Hotel, Beddgelert, another famous Snowdon hotel, which opened in 1802. At that time it was known as The New Inn and was built by Thomas Jones, a local landowner. The original landlord was David Pritchard, who combined farming and hotel keeping. It was a popular place and was patronised by the rich and famous. After a royal visit it was renamed the Royal Goat. It was described in the *North Wales Gazette* as 'a very capital inn with excellent accommodation'. Pritchard is reputed to have started the 'Gelert' myth, which is a major tourist attraction to this day.

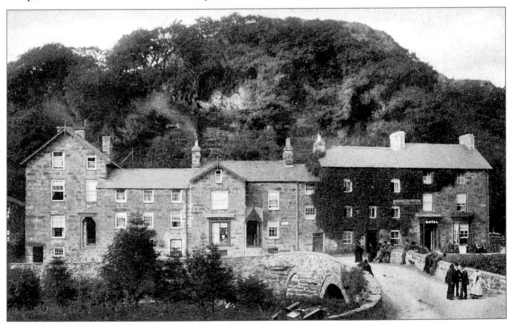

At 2.44 a.m. on 24 September 1949 the Prince Llewellyn Hotel in Beddgelert received a surprising visitor from space when a 1 lb 12 oz meteorite crashed through its roof. The lounge ceiling was holed and the meteorite embedded itself in the lounge floor. A replica of the meteorite exists in the hotel: half of the original is in Durham University and the other half is in the Natural History Museum, London. This is one of only two recorded meteorites in Wales in the past 200 years.

Idwal Cottage. This was the first youth hostel in Britain, and many of the great climbers of the 1930s and '40s stayed here. Colin Kirkus is said to have written most of the classic *Let's Go Climbing* while on a visit. Being a hostel, it makes most of the exciting Glydderau and Carneddau easily accessible to the mountain walker. The author recalls many nights spent there in the 1950s, tussling with the primitive cooking and clothes-drying facilities. Above the kitchen door was the sign 'Twll Ddu, the Devil's Kitchen' and indeed it was. The balcony at the end of the building was the prime sleeping area and much fought over.

Ogwen Cottage is on the shores of Llyn Ogwen and in sight of Tryfan. Although it was described in early literature as 'a humble and seedy inn', it attracted every major name in British mountaineering. Charles Kingsley stayed here and fished in the lake. The Abraham brothers took this photograph in about 1910. It was in this building that the brothers had their last climbing holiday with the great O.G. Jones. Four months after his stay he was killed in an Alpine climbing accident. The building has been much changed since and is now the local authority Mountain Centre.

Over the years, with progressively efficient transport systems, the need for a large residential hotel trade diminished. Hotels, without a local community to sustain them, found times very hard. Many changed their ways, and bar meals and early evening drinks became the norm, with bar lunches the biggest part of their trade. There was an increase in climbing huts owned by climbing clubs, as the social mix of climbers changed to encompass people from all walks of life. These huts offered spartan conditions and shelter at minimal cost. The spread of the youth hostel movement with cheap boarding facilities was a boon for the less well off, as the author can testify. Many of the establishments that had started their lives as hotels had to bow to the inevitable and become youth hostels, mountain training centres or local authority hostels. The photographs on this page show two buildings that made the transition, Plas Curig (above) and the Snowdon Ranger (below).

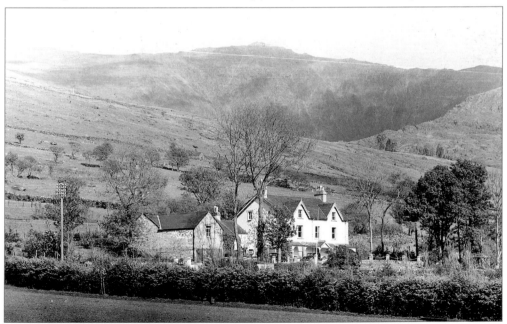

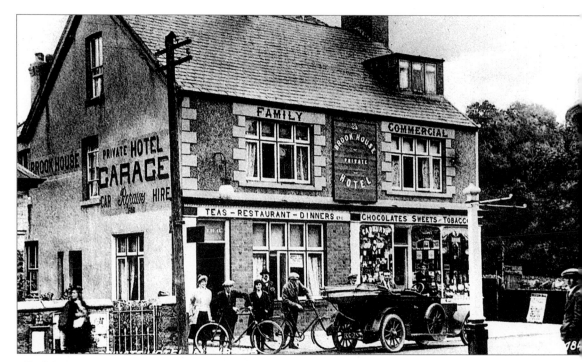

All of the towns and large villages within Snowdonia contained small commercial hotels and bed and breakfa
establishments that catered for the less well off as tourism expanded after the turn of the nineteenth centur
Motor cars, bicycles and motorcycles were beginning to fill the roads and speed through the mountain passe
opening up an area which had hitherto been the prerogative of the wealthier middle classes. These tw
photographs were taken in Llanberis in the 1920s.

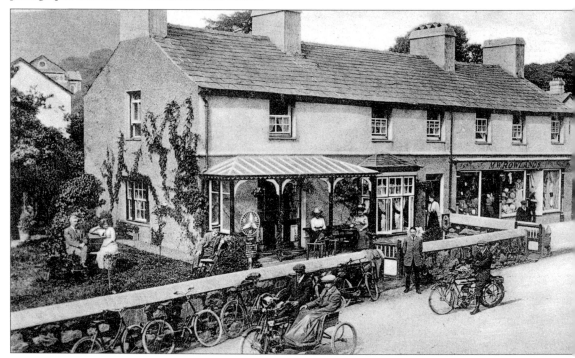

CHAPTER TEN

INDUSTRIES
IN SNOWDONIA

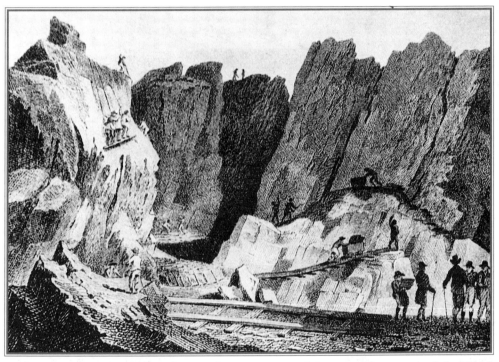

In the mid-nineteenth century slate production accounted for over 50 per cent of the Welsh economy. Slate is part of the heart of Wales, and the remains of the industry – in spoil-heaps, scarred mountainsides and deep pits – reveal a disregard for beauty in the struggle for existence. The industry was responsible for the creation of communities throughout Snowdonia: Blaenau Ffestiniog, Bethesda, Llanberis, Dolwyddelan, and the smaller hamlets of Bethel, Carmel, Deiniolen and Pen y Groes, for example, owe their existence to slate production. These communities were proud of the unique way of life that quarrying engendered, even though the menfolk were subjected to appalling working conditions. The physical hazards that quarrying involved resulted in the deaths of 258 men between 1826 and 1875 in Penrhyn Quarry alone, and a government inquiry revealed that the death rate of underground slate workers exceeded that in the coal mines. The more obvious effects were accompanied by the less apparent insidious industrial diseases such as silicosis, which disabled, crippled and killed.

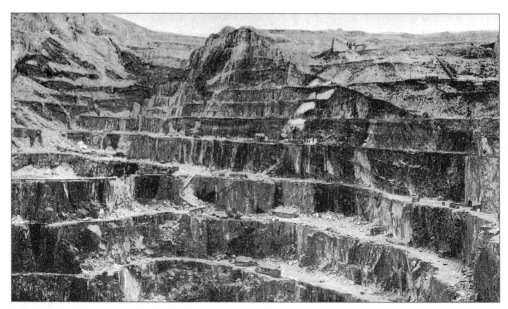

The Penrhyn Quarries at Bethesda form a vast amphitheatre over 1,000 ft deep. Quarry work has gone on here since the fifteenth century, and possibly before that. The quarry is worked in twenty-one galleries, or terraces, out of Bron Llwyd, the last shoulder of the Glyders. The terraces are between about 20 and 65 ft deep. It is reckoned to be the deepest slate quarry in the world, and the total workings cover some 560 acres. Within the 1¼ mile length of the pit there were 50 miles of tramway and the whole was linked to Port Penrhyn, Bangor by a 6-mile narrow-gauge railway, the first narrow-gauge tramway ever laid. James Greenfield first introduced the gallery system in 1797. On each gallery level, huts can be seen; these are the famous 'cabans' where the men ate their meals. They were the cultural centres of the pit where serious philosophical discussion, political debate, eisteddfodau and hearty choral singing were encouraged.

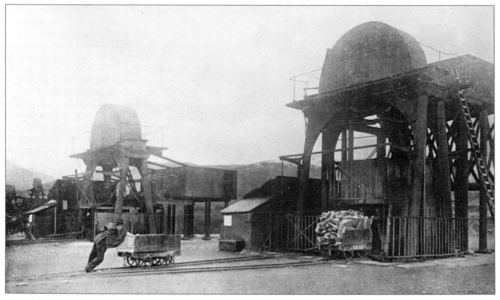

This late nineteenth-century photograph shows the water balance at Penrhyn Quarry. Empty wagons on platforms would descend with a tank full of water beneath, while full wagons with an empty tank would be hauled up.

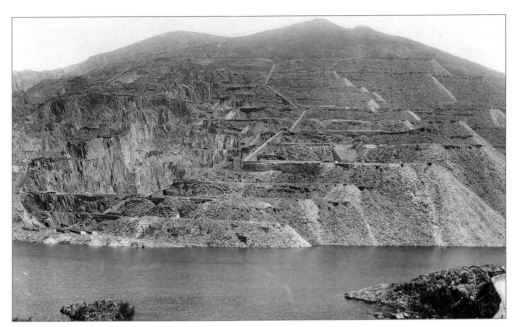

The Dinorwic Quarry was situated on the side of the Elidir mountain above Llanberis. Originally, in the early eighteenth century, small workings were scattered about the mountainside and these were amalgamated in 1787. The lord of the manor was Thomas Assheton Smith and eventually he, with others, owned the quarry. The railway to Port Dinorwic was built in 1824, and rebuilt to cater for steam in 1841–2. New workshops were erected in 1870, and they became a quarry museum in 1972. The quarry was not 'pit like' in form; instead, terraces were cut into the mountainside and these were connected by inclined planes. In its heyday it employed upward of 2,500 men and its annual output was 87,429 tons. When it closed in 1969 it employed 300 men; its closure was an economic disaster for the area. The quarry is now owned by Penrhyn Quarries Limited but there is no more working, just a great ugly scar against the mountainside. The quarry museum is well worth a visit.

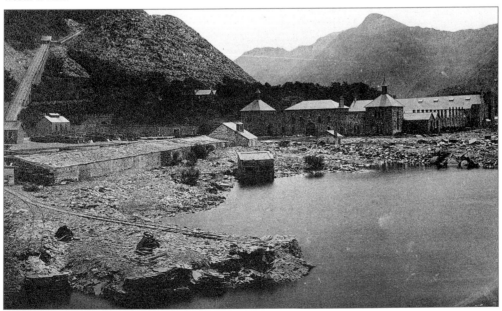

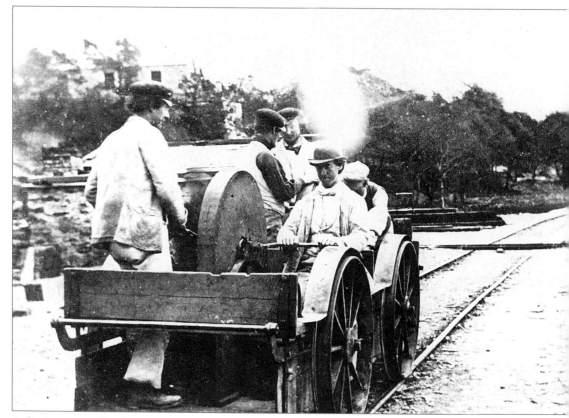

A distinctive mode of transport in the Dinorwic Quarry was 'The Velocipede', shown here. This very ra[re]
photograph was used on an early Victorian carte de visite.

The more distant economic effects of the slate quarrying industry were felt in all parts of North Wales;
example, vast transport infrastructures were established to sustain the industry, ships were built and ports we[re]
enlarged at Porthmadog, Bangor, Caernarfon, Dinorwic and Aberdyfi, and railways linked the ports and quarries

In 1882, 494,000 tons of slate were produced in Great Britain, 92 per cent of which came from Wales.
1898, 16,766 men were employed in the industry in North Wales. In 1880 the town of Blaenau Ffestiniog serv[ed]
eighteen quarries with about 4,000 quarrymen; nowadays there are two quarries working in the area employi[ng]
some 150 workers. Following the industry's heyday at the end of the nineteenth century a period of industr[ial]
unrest, foreign imports of cheap slate, the First World War and new roofing substitutes led to a catastrop[hic]
decline, so that by 1972 less than a thousand men were employed in the industry. The knock-on effects of this h[ad]
a dramatic impact on the economy of North Wales.

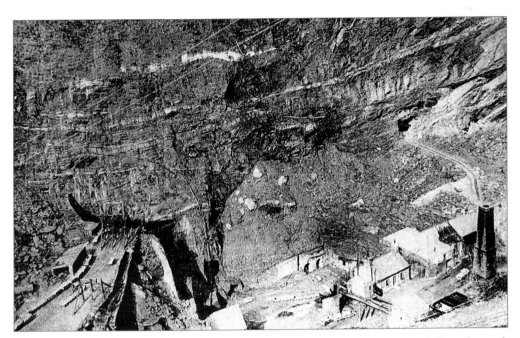

Where veins of slate dip underground in a gentle slope, it is necessary to follow the rock underground; thus slate mines, as opposed to quarries, came into existence, principally in the Blaenau Ffestiniog area. The method was introduced into North Wales from Cumbria by William Turner and Thomas Casson (1798–9) in the Conwy Valley, and Diffws Quarry, Blaenau Ffestiniog. The technique as called 'chamber and pillar' because large cavities were carved out, but some of the slate was left in pillars to maintain the roof. Frequently, 30 per cent of good slate was left underground forming the pillars (often walls) of roof support.

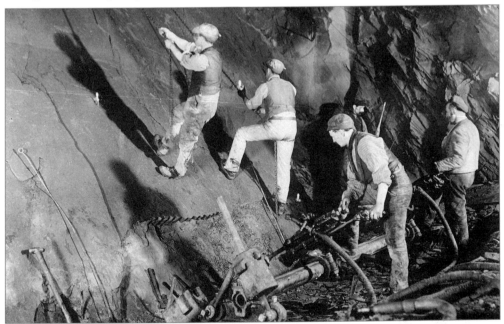

Men working by candlelight in a chamber in the Oakeley Mine. The compressed air drills they are using were first used towards the end of the nineteenth century.

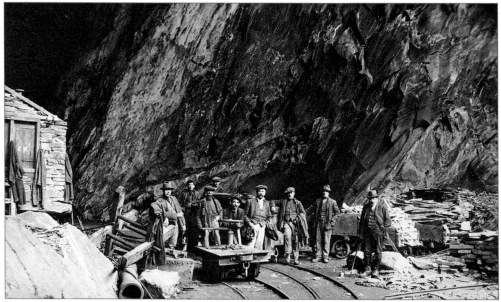

The Oakley (Gloddfa Ganol) Mine, Blaenau Ffestiniog, grew from the amalgamation of eight smaller workings. In 1890 it was the third largest slate producer in Wales, manufacturing in excess of 60,000 tons of slate in a good year; 1,700 men were employed here. The workings rose from sea level to 1,500 ft above sea level in 32 floors. A vast industrial concern involving 50 miles of railway with 12 dressing mills were on site. The machines used steam power exclusively and this drove 53 saw tables and 53 dressing mills. There was housing for 30 workers and their families, and the quarry had its own hospital.

Every ton of slate required the removal of a further 9 to 12 tons of waste – the 'make to waste' ratio. In some quarries 'make to waste' was much higher; for example, in Corris Aberllefenni the ratio was 1 to 67.

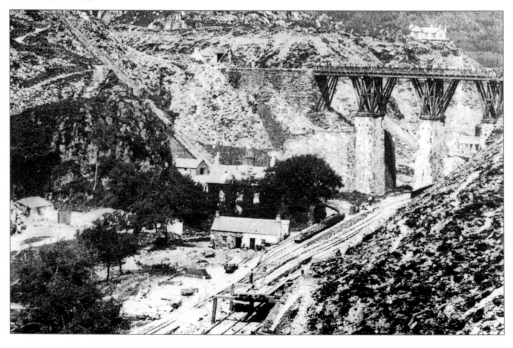

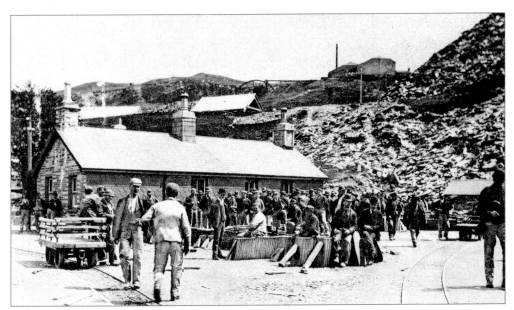

Pay day at Llechwedd Mine, *c.* 1910 (above). Complicated wage arrangements existed throughout the early years of quarrying, with various bargaining systems being struck between the mine and quarry owners and the quarrymen. Difficulties exist then in determining the precise conditions under which the quarry families lived; the only certainty is the owners prospered at the expense of the workers. It was ever so! Morgan Richards, one of the founders of the North Wales Quarrymen's Union, graphically described working and pay conditions in 1876: '. . . to walk five miles before six in the morning, and the same distance home after six in the evening; to work hard from six to six; to dine on cold coffee or cup of buttermilk, and a slice of bread and butter; and to support (as some of them had to) a family of perhaps of five, eight or ten children on wages averaging from 12*s* to 16*s* a week'. In 1850 average wages for all workers was less than 2*s* a day, in 1874 it was just over 6*s*, and in 1891, following a reduction in demand for slate, it was 4*s*.

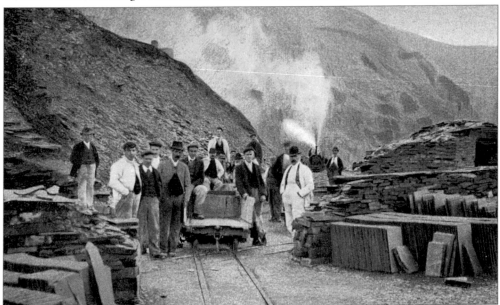

A break for a photograph. Penrhyn Quarry, *c.* 1905.

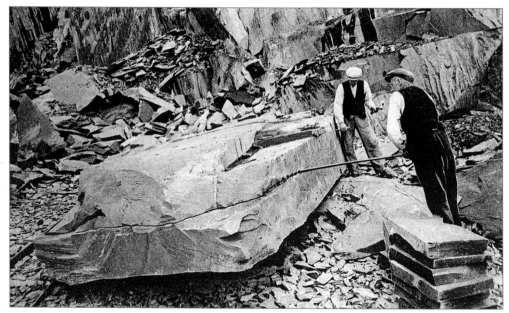

Slate was quarried and dressed by a system of bargaining. An agreement was drawn up between management and men (four to six in a group) to work an area of rock for a fixed wage with bonuses according to the amount of slate produced. Half of the group would work at the rock face extracting the blocks and the other half would dress the blocks. In the early days slate was dressed out on the quarry floor but eventually a factory-type system of roughly covered shelters was instigated, with slate stacked outside the buildings in long rows. 'Big Rhys' (a large mallet) was used initially to make the blocks manageable. As the process became more mechanised permanent dressing sheds were constructed with water, and steam power incorporated.

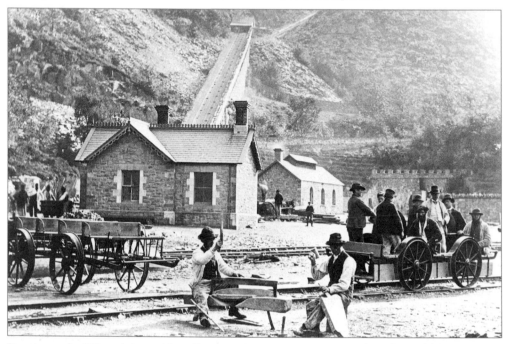

Dressing and splitting slate outside at Dinorwic Quarry, *c*. 1900. Note 'The Velocipede' (see p. 122).

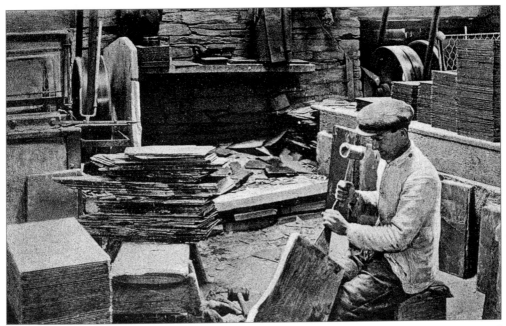

Slate splitting was never satisfactorily mechanised. A slate splitter (above) makes a very difficult and precise task look easy. The slate is split again and again along a cleavage plane with a broad chisel struck gently with an iron-bound mallet until a slate thickness of approximately $\frac{1}{16}$ in is achieved. A good slate can be split even finer than this. Some of the exhibition work created by splitters in fan ornaments, for example, demonstrates an amazing skill in splitting to almost paper-thin wafers. As it is, a good splitter could produce an average of twelve thin best-quality slates from a 2 in slab of good quality slate. The photograph below shows a group of 'rubblers' (apprentices) demonstrating their ability in a Ffestiniog shed early in the twentieth century. This process can be seen at the North Wales Quarrying Museum in the former Dinorwic Quarry, Llanberis.

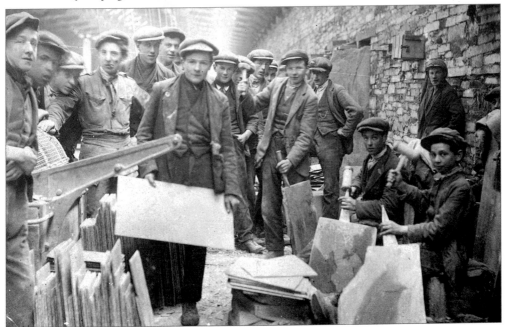

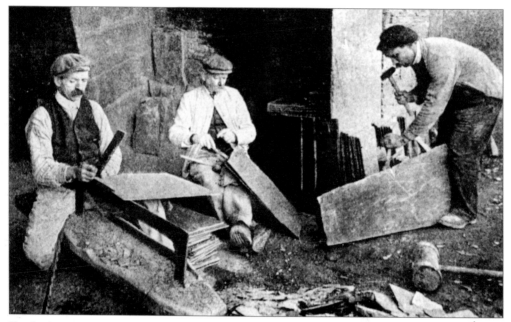

Hand trimming was a process of skill, with the trimmer sitting astride a wooden horse with an upright iron edge (trammel) against which he cut the slate to the required size with an iron-edged blade. The size was marked with a measuring stick, which had a nail at one end and was marked in steps of 1 and 2 in.

Mechanical trimmers were used mainly in the Blaenau Ffestiniog area; hand trimming persisted in the Caernarfonshire quarries into the 1960s. Two types of machine were used: the Francis, invented by a manager of Penrhyn Quarry, and the Greaves machines of Blaenau Ffestiniog. They could be either treadle or power operated and involved swinging blades or blades operating in guillotine fashion. Interesting names were given to the various sizes of roofing slate, called usually after the names of noble ladies, ranging from 'Empresses' (20 × 16 in), through 'Broad ladies' and 'Narrow ladies', to 'Single' (10 × 5 in). There were some eighteen different sizes in all.

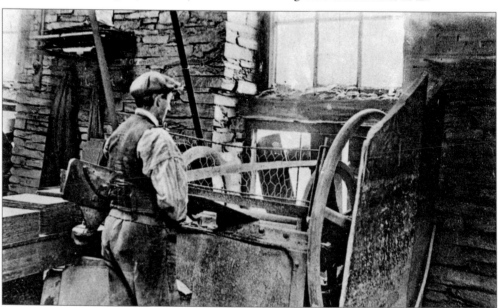

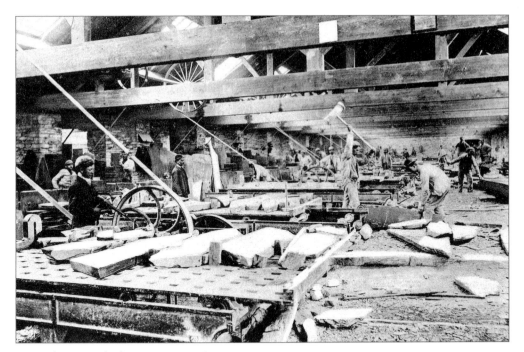

Powered saws made their appearance in about 1850 after some years of hesitant experimentation, initially in the Ffestiniog area, and only much later in the northern quarries. Blocks were first wedged along their cleavage plane to make them a manageable thickness; then they were placed on a moving table which carried the block towards a circular saw revolving at slow speed and well lubricated with water and sand. Later, high-speed diamond blades were used with a stationary table and a moving blade. Water was used not only to lubricate the blades but also to reduce the prodigious amount of dust generated, which was a prime cause of silicosis, the killer lung disease.

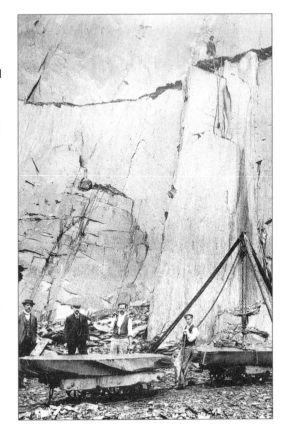

In addition to roofing slates, slabs were produced by some quarries for use as window sills, electrical switchboards, billiard table bases etc. Often these would be highly polished for use perhaps as ornamental gravestones or memorial plaques. It was usually the slab producers who installed the slate saws as seen above. The blocks shown here at Penrhyn Quarry in 1907 are said to have become the slate base of the billiard table belonging to Edward VII.

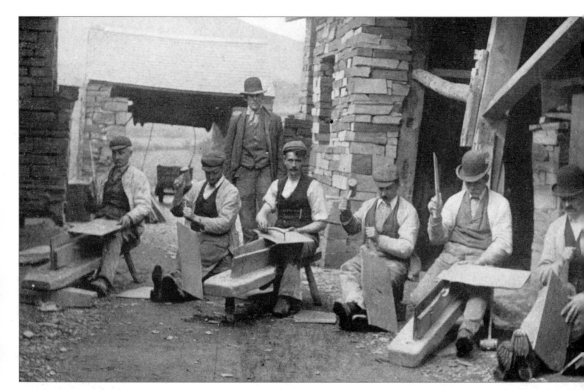

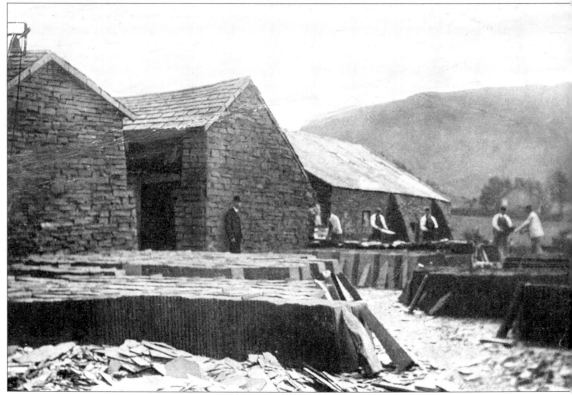

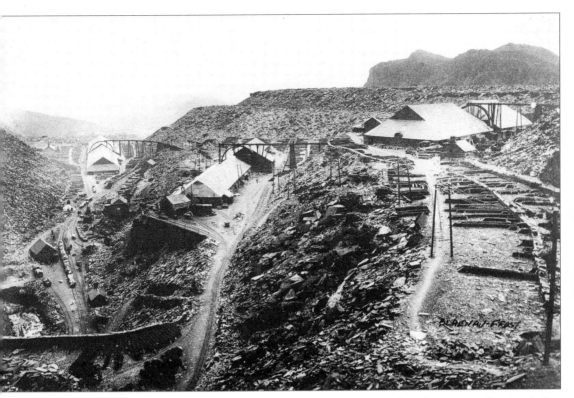

This photograph was taken at the beginning of the end for the industry in North Wales. It was taken just before the First World War, which led to a reduced demand for roofing slates. After the war industrial unrest hampered the progress of the industry and modern tiling techniques were mass-producing new roofing substitutes. The picture shows the Votty and Bowydd Mines at Blaenau Ffestiniog. There are three dressing mills seen, with waterwheels centrally located to provide power for dressing and splitting. There was an extensive tramway system and the photograph shows piles of finished slates as well as the growing piles of slate waste, which remains a feature of the area. The quarry went on producing slate until 1963.

Opposite: A group of workers at Tynybryn Slate Quarry at Dolwyddelan in the Lledr Valley, *c.* 1895. The quarry opened in 1840 and it became a significant source of slate production after 1861 when it was leased from the Gwydr Company by a firm from Manchester. Significantly, almost all of the North Wales's slate ventures were owned by Englishmen. In 1890 the quarry was sold to Thomas Mandle and production limped along until 1924 when it closed. At its peak it provided work for some forty to sixty men. The men shown in the photograph above are splitting and dressing roofing slates, before they are transported to the quarry wharf, as in the photograph below.

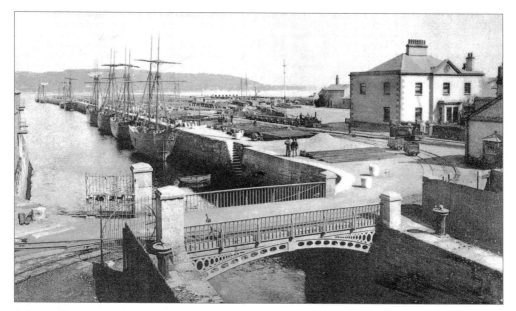

Port Penrhyn (originally Abercegin) was a small inlet on the shores of the Menai Strait until late in the eighteenth century. Around 1790 it was converted by Lord Penrhyn into 'a commodious harbour, capable of admitting vessels 300 tons burden, for more conveniently exporting the slate from his quarries about six miles distant'. The photograph, taken in about 1890, shows stockpiled slates and offloading from narrow-gauge trucks. The quarry to port tram road was completed in 1801. A standard-gauge link with the Chester and Holyhead Railway was built in 1852.

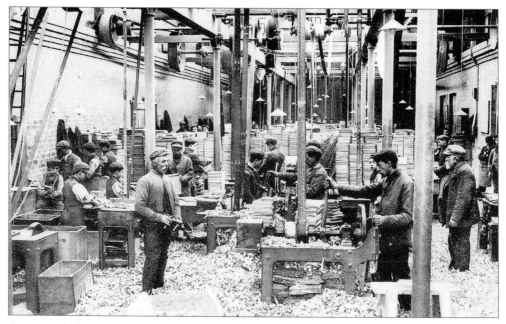

Conveniently built near the port, Lord Penrhyn set up a factory for the manufacture of writing slates. The aim was to undersell the Dutch providers of slates but, according to Pennant, the main opposition came from Switzerland. In 1809 about 136,000 writing slates were exported from Bangor. This represents the origins of the squeaks that have set millions of teeth on edge in classrooms across the world.

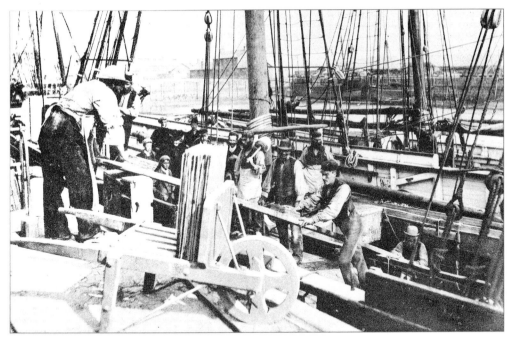

Porthmadog Harbour, c. 1900. During the period 1825–1914 the most famous harbour active in the export of slate was Porthmadog. Slate from the quarries at Blaenau Ffestiniog were brought to the harbour by the world-renowned narrow-gauge railway. The tonnage of slate increased from 4,275 in 1836 to 120,426 in 1882, the peak year. The port owes its creation to the massive 'cob' built by William Alexander Madocks in 1825. Various quarry owners constructed quays to facilitate loading. The demand for shipping led to the development of a thriving shipbuilding industry at the port.

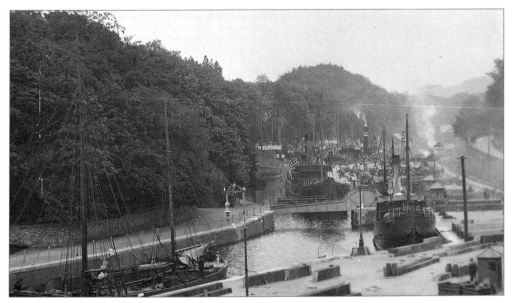

Port Dinorwic, c. 1908. Port Dinorwic (y Felinheli) linked the Menai Strait with the Dinorwic Quarry, 7 miles inland at Llanberis, by a tramway built in 1824. The building of the railway in 1840 improved transport and allowed for the export of some 150 tons of slate a day.

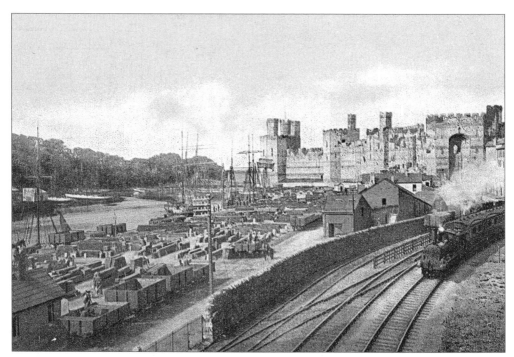

A busy industrial scene under the shadow of Caernarfon Castle with the slate quay in the foreground. A much earlier Gastineau engraving of the slate quay shows the sailing ships being loaded from horse-drawn carts. The narrow-gauge railway, which followed, was a faster, cheaper and much more efficient system. The linkage of standard-gauge rails through North Wales led to the demise of most of the North Wales ports.

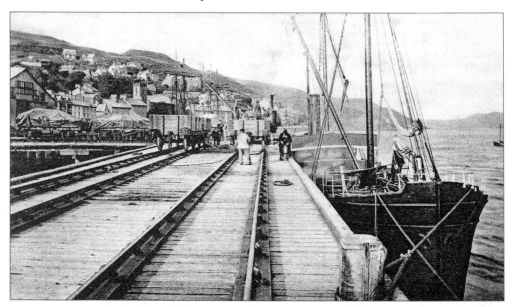

Aberdyfi, towards the end of the nineteenth century. A railway along the coast in the 1860s linked the port with Tywyn, and the inland slate districts. Slates came from the Abergynolwyn quarries by the narrow-gauge Tal y Llyn railway. By 1880 the port was slowly coming to the end of its active period, and the slate industry contracted its influence spasmodically until expiring in about 1900.

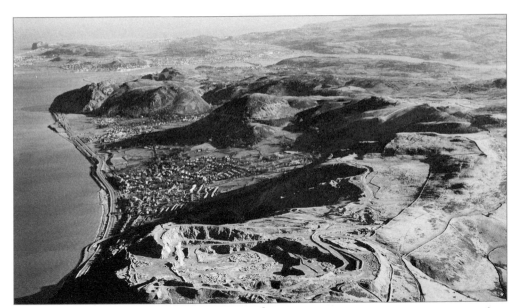

There has always been a demand for stone from Penmaenmawr and the mountain is only a fraction of its former self. Quarrying started here in earnest in the late 1820s, but it had been going on since time immemorial, as the axe factory discovered near the summit testifies. The Craiglwyd axe industry dates from about 2000 BC, and extends for a mile or so around the mountain. It may have been worked by seasonal bands of Neolithic workers before the arrival of the first definite settlers on the coastal fringes. Archaeological evidence suggests that two main streams of Neolithic culture (western and north-east European) met and mingled on this mountain. Prehistoric axes of 'Pen' stone have been discovered in upward of forty sites all over Great Britain, but mainly in North Wales. By 1870 Penmaenmawr was producing between 60,000 and 70,000 tons of stone a year. Roads and buildings all over Europe are constructed of Penmaenmawr stone and the main ingredient of the Mersey Tunnel was quarried here.

The railway arrived along the coast in 1840, and the town became Prime Minister Gladstone's favourite holiday resort; fashion followed his preference, and the area became a significant tourist venue.

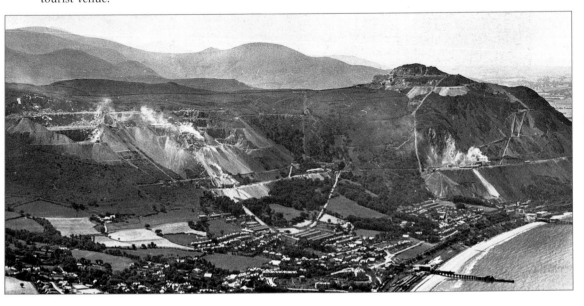

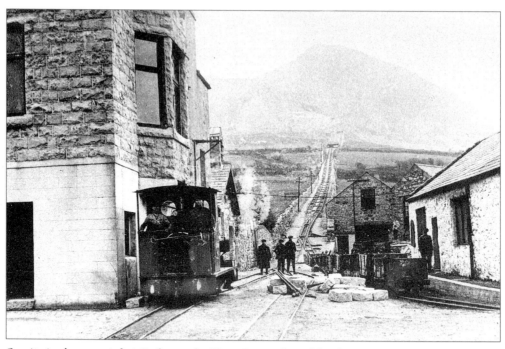

Granite is also quarried at Trefor on the Lleyn Peninsula and has been since 1850. Not long after the quarry opened the owners built a harbour and jetty. Granite was initially transported to the jetty by horse and cart, but the photograph below shows that eventually a steam train did the donkey work. The photograph above shows the quarry incline in 1930. The quarry, which supplied granite to all parts of Great Britain, closed in 1971, and now nature is reclaiming its own in the area. Recently the harbour and jetty have been modernised.

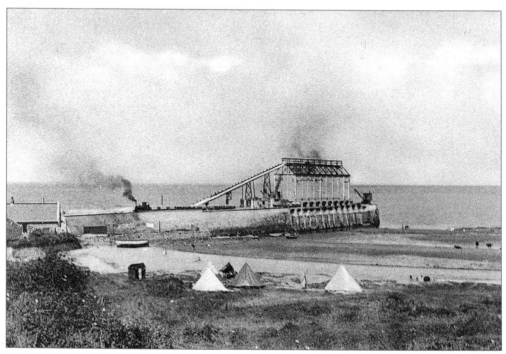

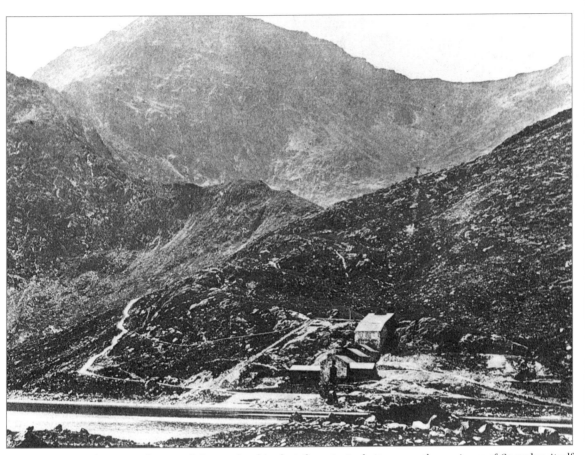

Copper was mined in several parts of Caernarfonshire but the principal sites were the environs of Snowdon itself and the Great Orme's Head at Llandudno. There was copper mining at Llanberis before the quarrying of slate became the major industry; copper dropped from an incline into boats on Llyn Padarn and it crossed the lake before being transported by road to Caernarfon. This photograph of the shores of Llyn Llydaw shows the Britannia crushing mills. This is the copper enterprise best-known to tourists because of its proximity to Snowdon. Several companies operated on the slopes of Snowdon including the Snowdon Mountain Company, the Cwm Dyli Rock and Green Lake Mining Company, and the Great Snowdon Mining Company. In 1898 the Britannia Company took over; it ceased working in 1916. Access to the workings was improved when the causeway was built across Llyn Llydaw and boating the ore was abandoned. A tramway around the shore was later replaced by an aerial ropeway to the mill.

Copper was mined extensively in North Wales, and on St David's Day in 1769 a big find on Anglesey led to Amlwch and Parys Mountain becoming the second biggest copper provider in Europe. In Snowdonia there are clear signs of copper extraction on Snowdon itself and this aerial view shows the mine workings in Cwm y Llan above the Watkin Path from Nant Gwynant. Snowdon shepherds earned a bonus by digging holes in the ground and humping the extracted ore on their backs down the mountainside. The first agreement on the Glaslyn Mine was signed in 1805. The mine at Drws y Coed in the Nantlle Valley, across the road from the Rhyd Ddu route to the summit, employed 100 men and was relatively productive, it was reputed to have been visited by Edward I in 1284. Copper was also mined at Beddgelert, and at Llanberis before the domination of the slate-quarrying industry.

Generally speaking not many fortunes were made, and it has been said that 'More money has gone into the holes in the ground than ever came out.' The isolated nature of the mines with attendant transport difficulties, and usually a running battle with mine flooding led to a faltering industry. The scars left by this activity will always remain as a testament to great effort expended for little reward.

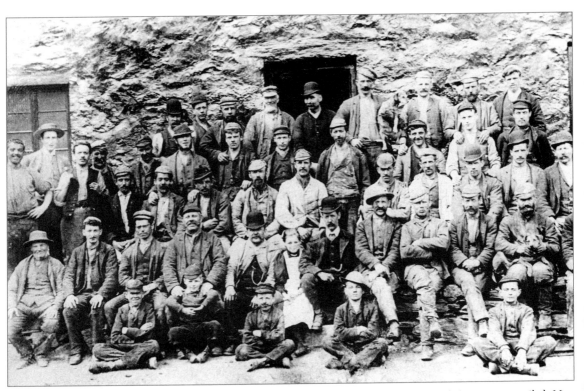

Because of the isolated and remote positions of pits and quarries in the area, the 'barracks' system prevailed. Men from villages in the vicinity of the work, for example Beddgelert and Llanberis, travelled to work on Monday morning, usually a long walk, and didn't return home until the following Saturday night. The photograph is of Llanberis men and boys posing outside the barracks at Glaslyn which were built in 1873 to house about a hundred men. Previous barracks had been built at Teryn in 1840. At Teryn the men lived with their families in one-roomed cottages, and a Welsh–Irish mixture of inhabitants relieved the boredom of their isolated existence by knocking 'seven bells' out of each other whenever the opportunities arose.

The building shown was two storeys, covered with an exterior coat of tar. The roof was lashed down with cables, which ran across it from iron stanchions hammered into the ground. There were cooking and bread-making facilities, but life must have been very uncomfortable. It didn't last long, however; like so many before it, the company went bankrupt before it was two years old.

It is difficult to imagine this lovely cwm as a hive of noisy industry but it was once, and the evidence is all around, including the remains of the building in the photograph.

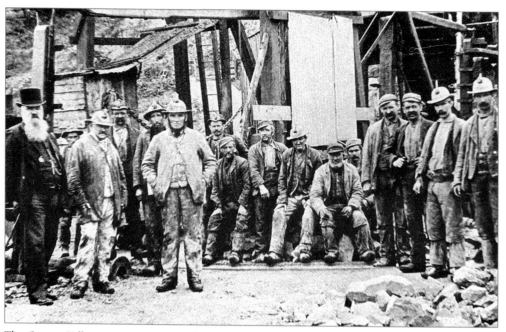

The Conwy Valley area was renowned as a producer of lead and zinc ores. The mine shown here was originally the Pyllau Cochion Mine but was taken over by Trecastell in 1894. The overshoot waterwheel was about 30 ft in diameter, and was used for pumping and winding. This was later replaced by steam power. This was a very productive mine, and between 1892 and 1913 it produced 6,448 tons of lead ore and 12,514 tons of zinc ore. The pit closed in 1920 but was reopened temporarily in 1950. The workings were abandoned in 1956.

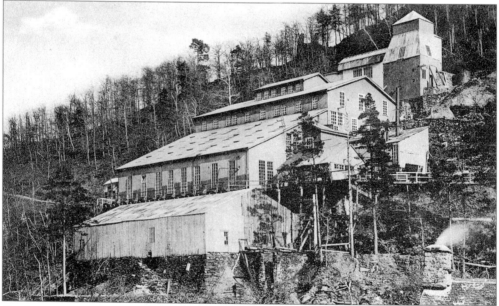

Glasdir Mine, *c.* 1900. This rather ugly building defaced the landscape near Dolgellau. Though it was a gold-mining area this quarry produced copper from about 1852. In the buildings shown, copper ore was crushed and refined, and between 1872 and 1914, 13,077 tons of ore were produced.

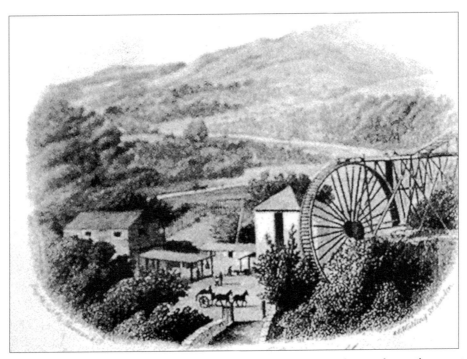

Among the metal ores found in the Snowdonia National Park, gold is the ore that strikes a note of excitement, and it has been found to the north of Dolgellau, along with lead, zinc and copper. Gold may have attracted the Romans here initially; a glimpse of glitter in the ripples of the Mawddach would have been sufficient. Two very early engravings show the primitive workings of the Clogau gold mines during the time of the gold rushes in the latter half of the nineteenth century.

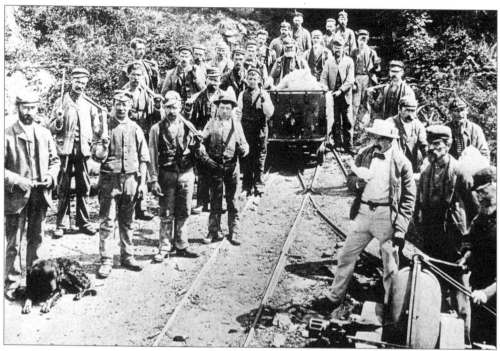

The gold mines of Snowdonia are in Merioneth and clustered in the Mawddach Valley north and west of Dolgellau. There were three mini 'gold rushes', in 1854, 1862 and 1887. There is some small-scale mining going on today at Clogau (above) and Gwynfynydd (below), and the latter is a thriving tourist attraction. Gold mined in Wales has been used in royal wedding rings since the wedding of George V. The industry peaked in 1904 when 19,655 oz of gold were extracted. Between 1861 and 1938, a total of 126,340 oz were refined from 279,278 tons of ore.

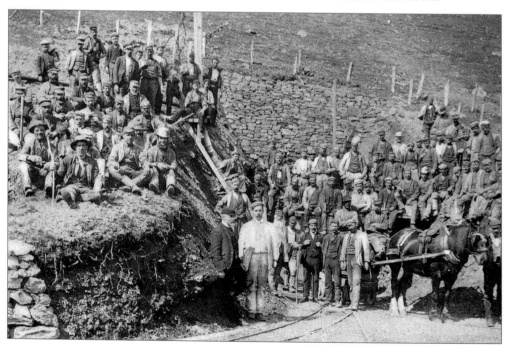

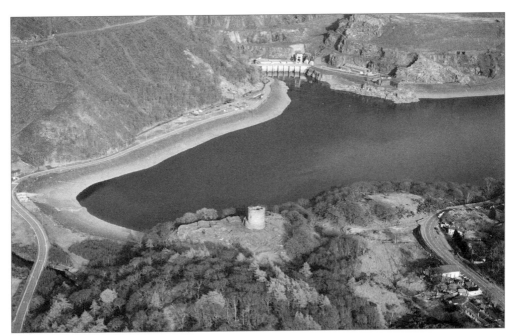

In this aerial photograph there is little visible evidence of one of the major engineering schemes in Europe. The Dinorwic Hydro Electric Pumped Storage System is buried in huge caverns beneath Elidir Fach. Three million tons of slate were removed to create the cavern which is twice the length and half the width of a soccer pitch, and is higher than a sixteen-storey building. During 'off peak' demand times water is pumped up the mountain from Llyn Peris shown here, stored in Llyn Marchlyn Mawr high above over the side of Elidir Fawr, and then released to drive the generators within the mountain as required. This scheme created storms of protest when it was under construction, and the hope is that it is not the forerunner of further schemes, which could prove to be one of the environmental disasters of the age. The photograph below shows a part of the interior of this vast undertaking within the mountain. Britain's first Pumped Storage Scheme was opened by Queen Elizabeth II on 10 August 1963 in another part of the park at Ffestiniog.

Prior to the arrival of electricity the power of water was harnessed in the area by way of waterwheels. Electricity arrived and was adopted in the late nineteenth century. It was soon realised that Snowdon's own water was readily available for power generation. In 1903 the North Wales Power and Traction Company was formed. The base of Cwm Dyli was chosen as the generator site and the waters of Llyn Llydaw which fell naturally into the cwm were the water source. Pipes replaced the natural stream, and they were laid on the surface; the result is the monstrous eyesore we see today. Add to this the power lines snaking from the plant and it was not a pretty sight; happily these were removed when Snowdonia became a national park.

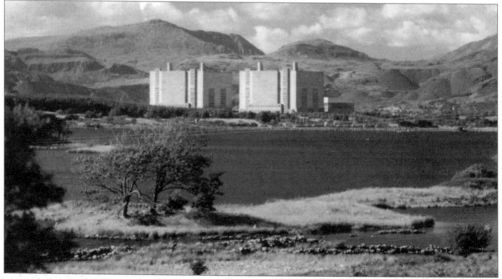

Trawsfynydd Lake was constructed in the late 1920s for the Maentwrog Hydro Electric Scheme, and as a Liverpool Corporation reservoir. In 1959 work began on a nuclear power station on the banks of the lake. It was to be the only inland commercial nuclear power station in the United Kingdom. In 1965 it started to produce electricity. The reactors were taken off-line in 1991, and formal closure was announced on 20 July 1993; decommissioning began in November 1995. Dismantling involves costly and complicated procedures, which are long running, and require the utmost caution. The knock-on effects of the loss of work for local men is devastating for, whatever criticisms might have been levelled at the project, it did provide employment in an area which needed it desperately.

Throughout history the area's natural tree species have succumbed to the demands made upon them by man. Deforestation has a multiplicity of causes but one, for example, was the Hafod-Hendre farming process by which young tree shoots were eaten by grazing sheep on the higher mountain slopes during spring and summer, and the lower slopes and valleys were cleared by farmers for winter grazing. Industrial demands such as shipbuilding, charcoal, and pit-prop requirements also cleared woodland. In 1920 the Forestry Commission began its work and established forests throughout Wales; the principal ones in North Wales were Gwydyr (above), and Coed y Brenin. Rapid wood production was the criterion for species choice and this, coupled with the constraints imposed by poor terrain and climatic conditions, led to a proliferation of spruce forest. These have caused a deal of controversy, not least because land use has changed from hill farming to forestry. The forest smoothes the rocky outcrops with an unnatural monotony, and kills the land it grows on. The environment produced has little charm for the fauna that would normally inhabit the land it occupies.

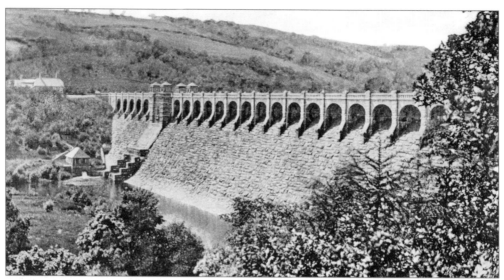

The liquid wealth of Wales has proved a contentious issue over the years, since vast tracts of lovely valleys have been blocked and flooded to provide water for English towns. 'Cofia Tryweryn' (Think of Tryweryn) was the battle cry when the village of Capel Celyn in the Tryweryn Valley was drowned in order that the people of Liverpool could be supplied with drinking water. This event, which took place in the 1960s despite almost universal protest throughout the principality, caused wounds that have never healed. 'CYMRU PIAU'R DWR' (meaning 'the Water Belongs to Wales'), was scrawled on the dam at Lake Vyrnwy, the largest artificial lake in Wales. The embers were rekindled in the 1980s when it was discovered that Welsh people were paying higher water rates than the English for their own water! Most reservoirs, such as Lake Vyrnwy, seen above soon after construction, were built in the nineteenth century, putting Welsh taps into millions of English kitchens. Reservoirs were built all over Wales, and in the picture below Edward VII is arriving to open the Elan Valley waterworks in Powys, south of Snowdonia. Four large reservoirs were built here between 1892 and 1904 to supply Birmingham.

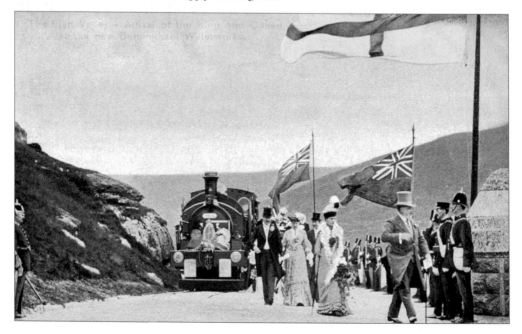

FARMING

The topographical and meteorological features of Snowdonia – broken, hilly terrain, poor mountain soil and high rainfall – determines the type of farming that prevails, namely largely pastoral. This type of farming predominated in Celtic culture when the hill-fort dwellers were first and foremost stock rearers. Some 95 per cent of Snowdonia is grassland with stock rearing still the norm. It has been said, perhaps too many times, that there are ten sheep for every person in North Wales, and the proportion is probably doubled if we consider only Snowdonia.

A Handbook to Caernarfonshire, written by the Revd N. Owen in 1792, was very critical of Welsh farming methods. He said of the tenant farmers: 'Prejudiced to the old mode of husbandry, they toil in the beaten track, and are not dissatisfied with their fortune if they can but barely pay the rent and maintain a homely subsistence.' A typical pattern for farming in the period in about 1800 would be a few oats grown in the valley, a cow or two near the cottage, and sheep wintered low but driven to the high pasture for the warmer months. In Hyde Hall's A Description of Caernarfonshire he noted that '. . . the old largely prevailed, peasant farming being the premier source of wealth; although it could be more fittingly described as a source of poverty'. When considering the mountain terrain, poor farming methods and harsh tenancy conditions, Hyde Hall concluded that the result '. . . is a more harassed and distressed race than I am acquainted with'. In recent times the farmers on Snowdonia's slopes have had a very hard time of it.

Transhumanance was a dominant feature in the early years of hill farming. This, the 'Hafod–Hendre' principle, meant that farming was conducted in two places depending on the season of the year. In the summer the cattle and sheep were moved up the mountain and farming went on around the Hafod (summer dwelling). In the winter the cattle were moved down into the valleys and lower mountain slopes, and farming continued around the Hendre (winter dwelling). The remains of Hafotai (Hafods) can still be seen dotted throughout Snowdonia, as in the photograph above. The national park authorities are anxious that the underlying principle be continued, and perhaps extended, so that between October and April the higher slopes of the hills can be rested for longer periods, with beneficial effects on developing flora and fauna.

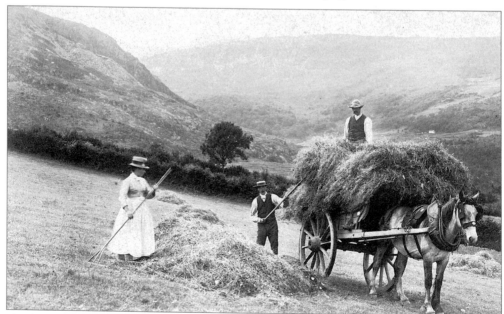

The hay harvest on the lusher meadow slopes of the Vale of Conwy above the village of Trefriw. Farming here is different altogether.

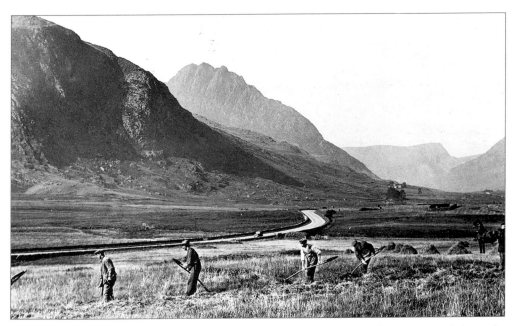

The cooperative nature of farming in Snowdonia. Neighbouring farmers have come to help in the harvest of the essential hay crop in the Nant Ffrancon Valley. The frequency and intensity of rainfall in the area means that when a harvesting opportunity arrives it must be seized with speed. Cereal crops were rarely, if ever, grown for market but were usually intended for home consumption: wheat for bread, oats for horses, barley for pigs and cattle. Work-sharing between neighbours and temporary labour from nearby townships such as Llanberis and Beddgelert was usual, with bartering the economic strategy.

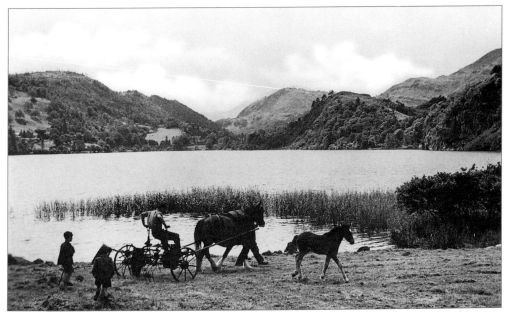

A contrasting scene in Nant Gwynant on the shores of the lake. Horsepowered mechanisation is being used to turn hay; an apprentice horse accompanies its mother. From here to the sea the terrain generally improves and farming is easier.

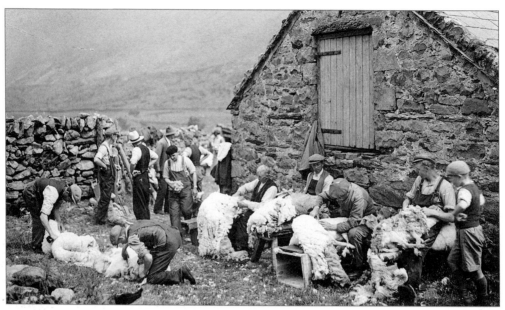

A communal shearing in the Nant Ffrancon Valley. The life of the Snowdonia shepherd has been well depicted in both literature and on film. The classic is perhaps Ronald Firbank's *I Bought A Mountain*, which graphically describes the everyday life of these hardy people; it is an enthralling read. Life has not been easy for sheep farmers in recent years; the lonely life, in harsh environmental conditions, has been made worse by the Chernobyl fall-out disaster in 1986, and marketing difficulties imposed by politicians who know no better. The farmers still pull together today.

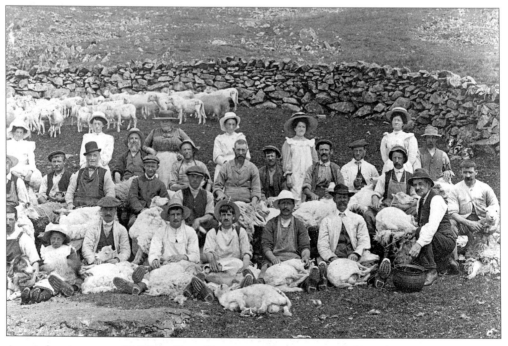

A post-shearing scene of 1907 in Blaen Lliw, near Bala. Every man holds a sheep, and the sheep on the extreme right knows that it is having its photograph taken.

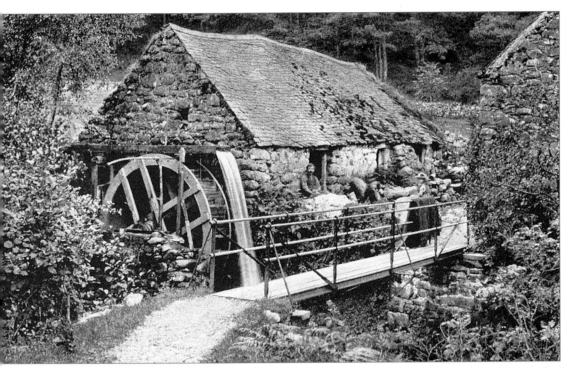

'Pandy' or fulling mill near Dolgellau, at the turn of the century. This photograph shows one example typical of many scattered through the woollen districts of North and Mid-Wales. They were placed wherever there was a river or stream powerful enough to drive a wheel. Fulling involves the pounding of woven cloth with wooden hammers to close the threads together to produce a flannel or felt-like material. Sometimes this arduous process was done by hand or foot, but it was much better, and of course less tiring, to harness the power of the many streams running through the area.

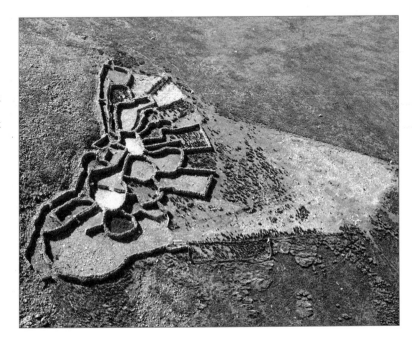

Sheep, cattle and goats leave their mark on the landscape, not least with the denuding of the mountain slopes and the subsequent loss of fertile soil through erosion. The proliferation of drystone walling, buildings, folds and folding pens is the result of sheep farming, and these are features that the national parks are anxious to preserve. The beautiful honeycombed structure shown here was photographed after there had been considerable restoration work carried out by National Trust workers. Situated in the Anafon Valley, this fold dates back probably 200 years, and was used communally for shepherding and sorting when mixed flocks were brought down from the mountainside for dimbing, shearing and so on.

Until the mid-nineteenth century the manufacture of woollen goods was the most important of industries in Wales. Most of the processing and production was carried out in many hundreds of small mills throughout the area. Farmers raised sheep and took their fleeces to the mill to be spun and woven into cloth for their families. The mill owner was paid in wool. The predominant areas were Dolgellau and Meirionydd where they produced webs, a white coarse cloth ⅞ yd wide and between 180 and 200 yd long. The industry was strangled by the monopoly held by the Shrewsbury Woollen Drapers' Society, and declined during the early years of the nineteenth century. Several of the early mills exist today, as does the one shown above. They are still producing traditional Welsh woven products, and are popular tourist attractions.

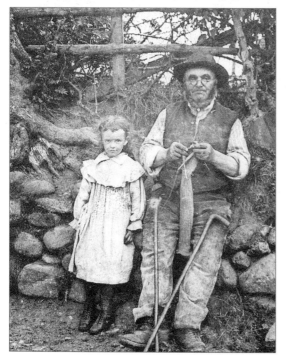

Another aspect of the woollen trade was hand knitting, a cottage industry which was widespread throughout the region. The area of particular note was Bala, though the towns of Llanrwst, Betwys y Coed, Blaenau Ffestiniog and many others were also recognised for their knitted products, mainly socks. In 1747 the average weekly sale of socks at Bala was £200 at 2s 6d per pair, namely 1,600 pairs. 'Nosweithiau Gwau' were community knitting evenings with songs and harp recitals. George III claimed that his rheumatism was considerably helped by the stockings knitted at Bala and would wear no others. Woollen caps produced in the area were known as 'Welsh Wigs' – Mr Fezziwig in *A Christmas Carol* wore a Welsh Wig.

THE GREAT LITTLE TRAINS

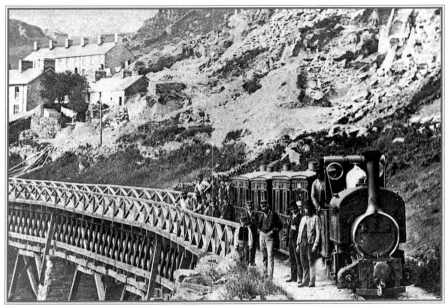

The narrow-gauge railways of North Wales originated as a means of transporting the area's mineral wealth from inland quarries and pits to the seaboard. The principal export was slate. Lines which once carried a million tons of slate each year now carry much the same number of tourists. The design and construction of the rolling stock and the narrow-gauge principle were forced on the engineers by the topography of the area. The gravity-motivated and horse-drawn wagons were admirably suited to an area of steep hills and narrow valleys, and later the introduction of steam engines – despite pessimistic noises coming from the great standard-gauge railway engineers – proved to be very successful. The Ffestiniog Railway is probably the most famous of the lines, but there were others connecting quarries with almost all of the little ports situated around the coasts and in the river estuaries. In all there were some fourteen major systems, with dozens of smaller lines in the quarries and mines dotted around the area.

The end of the slate boom at the turn of the nineteenth century led to many years of turmoil and uncertainty, and the closure of some lines. But, thanks to the energy and enterprise of dedicated enthusiasts, those that survive make a valuable contribution to the economy of an area greatly in need of it. The narrow-gauge railway systems are the most acceptable of the legacies left after the slate boom. Wales should be grateful for the work of the various preservation societies, which has led to the steady renovation of lines and stock so that they now exceed the quality they exhibited at their Victorian zenith.

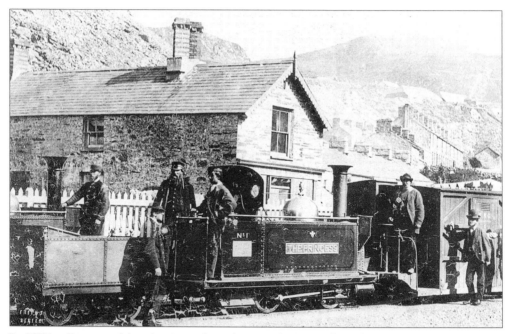

In 1876 a European delegation arrived in Blaenau Ffestiniog where the Ffestiniog Narrow-Gauge Railway was on display. Wales was leading the world in the field of transport. Mr Fairlie's bogies and Mr Spooner's track was the start of something that was to spread around the world. The system was revolutionising the transport of slate from quarry to seaport.

The Princess arrived at Ffestiniog in August 1863. The engine is attached to a prototype and very primitive passenger train. It was the first steam locomotive on the Ffestiniog Railway and, indeed, the first steam locomotive in the world for a public narrow-gauge railway. The engine has been exhibited widely and is now in the Ffestiniog Railway Museum.

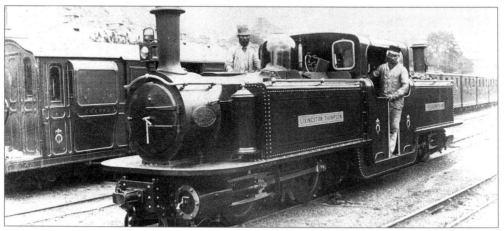

Livingstone Thompson was introduced to the Ffestiniog line in 1885. Over the years it has been much restored with two name changes: in 1957 it was called *Taliesin* and in 1961 it became *The Earl of Merioneth*. This, the double 'Fairlie' (invented by Robert Fairlie), is the one most associated with the line. The type were designed to provide maximum power in an engine that could negotiate the sharp curves and steep gradients of the line. The 'push me, pull you' revolutionary design looks like two engines back to back but is actually one long boiler with central fireboxes. The ends of the boiler are mounted on swivelling bogies. It was the first double Fairlie, *The Little Wonder*, that attracted the attention of the delegation mentioned earlier.

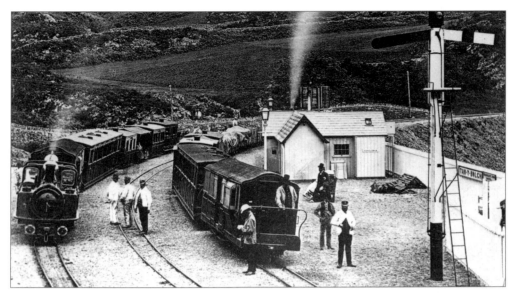

Tan y Bwlch station with two passenger trains, *c.* 1875. Passenger services had started in 1865, not long after the introduction of steam, using tiny four-wheeled carriages built in Birmingham. The engine on the left in the photograph is *James Spooner*; built in 1872 by Avonside, it was the second double Fairlie to be constructed. In 1896 the middle line seen in the photograph was removed. In 1946 the railway closed, but was reopened in 1955 after very hard work by dedicated enthusiasts.

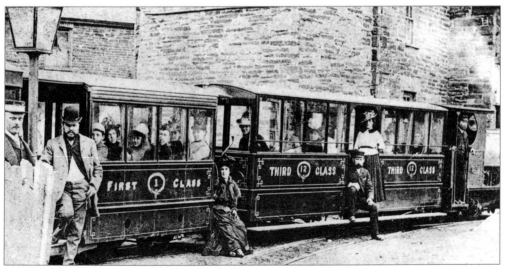

In 1859 the awkwardly named Corris, Machynlleth and River Dovey Tramroad opened from Aberllefenni by Corris to the Dovey Estuary. In 1863 it changed its name to the Corris Railway. Once again slate quarrying was the reason for the construction of the line. The village of Corris was surrounded by enormous slate tips from the quarries operating to the east and west. Horsepower was changed to steam in 1879, and passengers were carried from Machynlleth to Corris in 1883, before the service was extended to Aberllefenni in 1887. The Corris line was never very wealthy; the service was to a relatively impoverished rural community and, when the slate industry declined, the railway fell on hard times. There was also competition from the Cambrian line, which offered a service to Machynlleth. In 1948 the line was badly damaged following flooding in the Dovey Estuary and the line closed. Two locomotives and other stock were sold to the Talyllyn Railway in 1951.

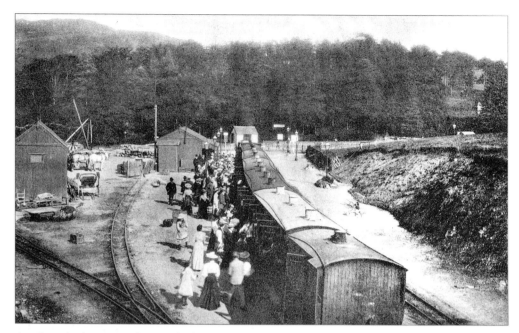

A railway built to capitalise on the beauty of the Rheidol Valley was first considered in 1861 and, unlike the other lines in North Wales, the tourist trade was a prime consideration when the Vale of Rheidol Light Railway was built. The bill for its construction was passed in 1896 and it eventually opened for business in 1902. The freight traffic, which consisted of the products of the lead-mining industry and forestation, started in August 1902, and passenger services began in December of that year. For most of its life the line has relied upon the tourist industry and it would have closed had it not been for this trade. The view above is of the Devil's Bridge station with tourists boarding the train after viewing the spectacular waterfalls from Jacob's Ladder. The goods sidings are on the left; lead ore was brought here by horse tram to be loaded on to the narrow-gauge wagons. Below, a train is on its way to Devil's Bridge.

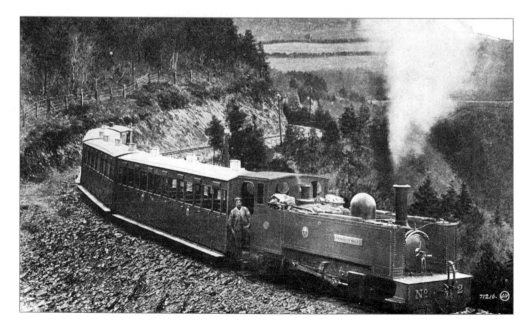

The Welsh Highland Railway has a complicated history, involving the merging of four other companies to build a network linking Caernarfon with Beddgelert, Betws y Coed, Corwen and Porthmadog. It opened in 1923 and the losses incurred each year resulted in a receiver being appointed in 1927. There was no improvement over six years and the line was closed in 1933. It was reopened in 1934 by the Ffestiniog Railway Company under a 42-year lease. The new company failed to make a go of it, and in 1937 the line ceased its operations. During the Second World War the track and equipment was used as salvage to help the war effort. Currently a preservation society is making efforts to revive the line, but the proposals are being met with opposition from environmentalists and local farmers. Vestiges of the line are seen on the side of Aberglaslyn Pass, where the vacated trackway has made a pleasant walk under two rather damp tunnels.

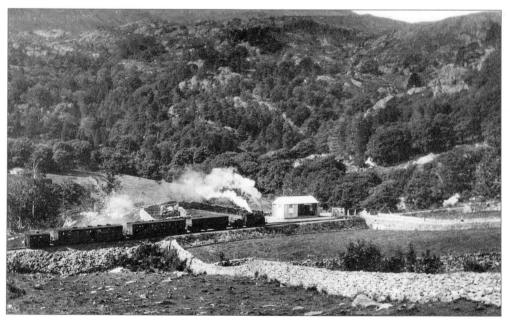

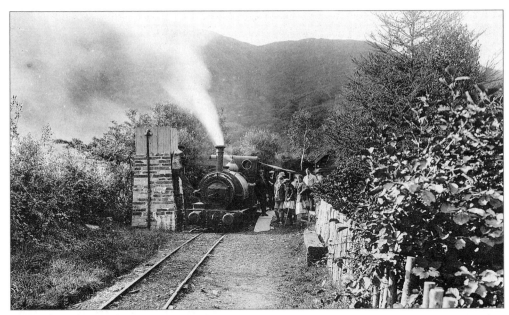

In 1950 a public meeting was called in Birmingham by L.T.C. Rolt, and at its conclusion the first railway preservation society in the world had been set up. Sir Haydn Jones, owner of the Talyllyn Railway, had died in the summer of 1950; the railway had survived – whilst others were closing all around it – only because Sir Haydn had been prepared to run it at a loss. On Whit Monday 1951 the railway was officially reopened, and carried in that year a record number of 15,000 passengers from Tywyn to Abergynolwen. In 1952 this rose to 22,000 passengers. The 6-mile Talyllyn Railway was started as a slate line in 1866 with a 2 ft 3 in gauge track but, right from the start, passenger and tourist potential was realised and catered for. It had the same gauge as the Corris Railway and there was an operational link between the two. When the Corris closed down its rolling stock was purchased to reinforce the Talyllyn stock. The two original engines were the *Dolgoch* and the *Talyllyn*, built by Fletcher Jennings and Co. of Whitehaven. The engines bought from the Corris line were *Sir Haydn* and *Edward Thomas*.

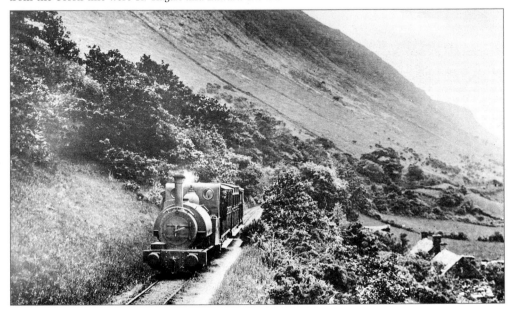

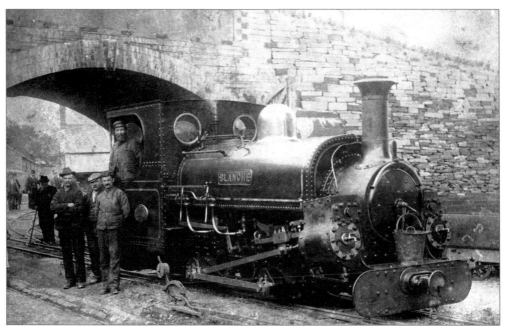

There were dozens of lines in the quarries spread throughout Snowdonia, far too many to receive any detailed consideration here. One must be singled out, however, as it was the first narrow-gauge line in the area, and the introduction of the system had such a dramatic impact upon working costs and conditions. Before the line existed slate had to be dragged on wheeled wagons from Bethesda to Bangor a distance of some 6 miles. In 1801 a track was laid and, in 1945, Lord Penrhyn's heir described the effect. Prior to the track being laid the cost of transport equalled the cost of production, and 140 men and 400 horses were employed. After the track was built a larger amount of slate was carried in the same time by 16 horses and 12 men and boys. In 1879 a new line was constructed for steam locomotives, and in 1893 *Blanche* (above), and her sister *Linda* arrived. In 1963 *Blanche* was bought by the Ffestiniog line and was rebuilt in 1972. The photograph below shows *Glyder* on the third level of the Penrhyn Quarry in 1947.

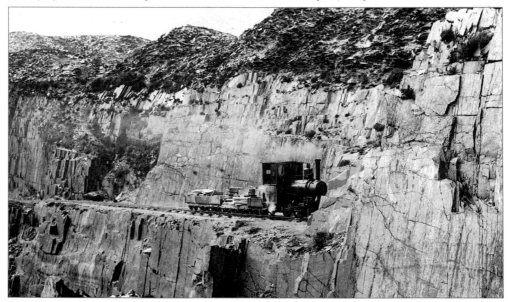

ACKNOWLEDGEMENTS

Special thanks go to Harvey Lloyd, who was the Warden of the Pen y Pass Youth Hostel for twenty-five years between 1972 and 1997. He has given freely of his time and knowledge, and made his archives available to me. This book would not have been possible without his help.

Many more people gave invaluable help: Roger Brown ARPS provided the aerial photographs, Derek Blamire, Jim Boulton, John Cowell, Mike Day, Geoff Ellis, Ted Gerry, Karlyn Goulborn, the late David Hughes, Bryan Hurst, Glyn Jones, Wyn Jones, Andrew Morley, Sue Morley, Gwyn Morris, John Murgatroyd, Jack Owen, Frances Richardson, John Roberts, and Peter Roberts. Also the staff of Trawsfynydd Power Station and the Llanberis Hydro Electric Scheme, Lancaster University Abraham Brother's Archive, and Llandudno Library staff.

Many books were consulted, too many to mention, but the late D.L.F. Hoare's book *Snowdon: That Most Celebrated Hill* (1987), was a mine of well-researched and well-written information.

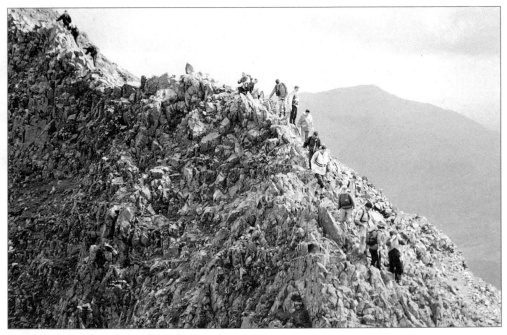

A crowded 'Horseshoe' in the 1990s.